CHURCHES OF CORNWALL

JOANNA MATTINGLY

AMBERLEY

To my husband Alex

This edition first published 2023

Amberley Publishing
The Hill, Stroud
Gloucestershire GL5 4EP

www.amberley-books.com

British Library Cataloguing in Publication Data.
A catalogue record for this book is available from the British Library.

ISBN 978 1 3981 0697 0 (print)
ISBN 978 1 3981 0698 7 (ebook)

Typesetting by SJmagic DESIGN SERVICES, India.
Printed in Great Britain.

CONTENTS

Numbers in brackets refer to the chronology of the initial stories selected, starting with the sixth-century chi-rho stone at St Just in Penwith.

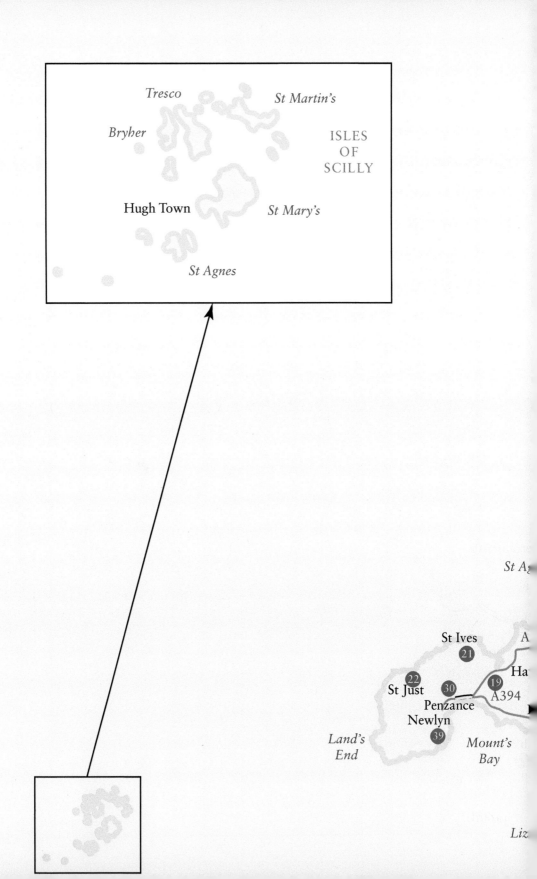

Tresco

St Martin's

Bryher

ISLES
OF
SCILLY

Hugh Town

St Mary's

St Agnes

St A

St Ives
21

A

Ha

22
St Just

30
A394

19

Penzance
Newlyn

39

Land's
End

Mount's
Bay

Liz

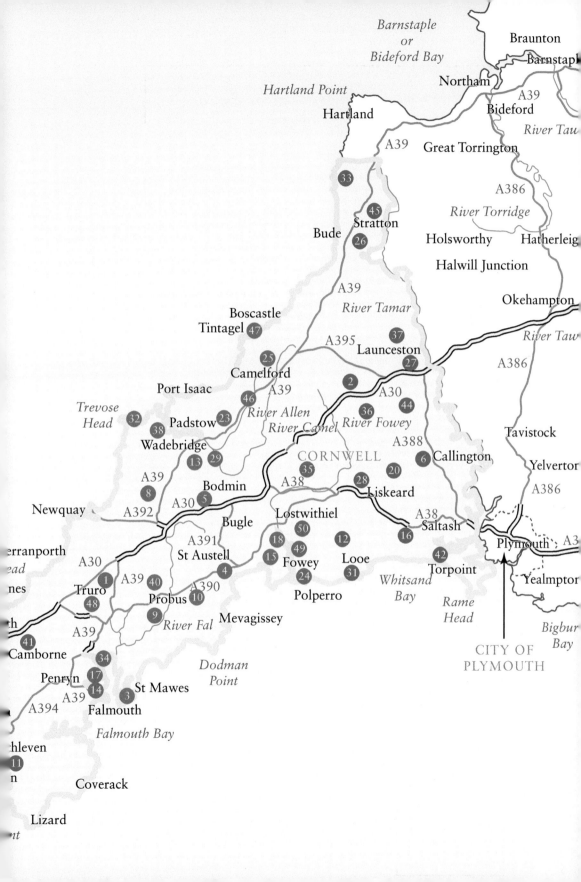

KEY

1. St Allen
2. Altarnun
3. St Anthony in Roseland
4. Austell, St
5. Bodmin
6. Callington
7. Camborne
8. St Columb Major
9. Cornelly
10. Creed
11. Cury
12. Duloe
13. Egloshayle
14. Falmouth
15. Fowey
16. St Germans
17. St Gluvias
18. Golant, St Sampson
19. St Hilary
20. St Ive
21. St Ives
22. St Just in Penwith
23. St Kew
24. Lansallos
25. Lanteglos by Camelford

26. Launcells
27. Launceston, St Mary Magdalene
28. Liskeard
29. St Mabyn
30. Madron
31. St Martin by Looe
32. St Merryn
33. Morwenstow
34. Mylor
35. St Neot
36. North Hill
37. North Petherwin
38. Padstow
39. Paul
40. Probus
41. Redruth
42. Sheviock
43. Sithney
44. South Petherwin
45. Stratton
46. St Teath
47. Tintagel
48. Truro, St Mary Portal
49. St Veep
50. St Winnow

INTRODUCTION

More fifty shades of granite than Pevsner, these Cornish building stories start in the sixth century AD and end in the 2000s. Stories are arranged alphabetically by parish (ignoring the St prefix), but numbered chronologically by the initial story to provide an alternative way into this book. This gives an overview of Cornish architectural development from early Christian memorial stones, through Norman and Gothic architecture, the Reformation, Civil War iconoclasm, Georgian vandalism and Victorian restorations, to the building of a new Roman Catholic church for Truro. Building tales include a murder, a vicar's concubine, fundraising sheep, an ambush, a Plantagenet wedding, a post-Armada terror raid and a Good Friday fire caused by a faulty stove. What is clear throughout is that Cornish church history, like the buildings themselves, is never simple.

In the Norman or Romanesque period (1066–1200s) Cornish churches were two-cell (chancel and nave) structures, sometimes taller than at present, and with a bell turret or tower. Built for Catholic worship, major churches in this period had lean-to aisles and clerestories and used a wide variety of local and imported stone including Catacleuse from St Merryn parish near Padstow for some of the many surviving Norman fonts. Towers could be centrally placed, attached to transepts, or at the west end. A brief Transitional period linked Norman and Early English Gothic which covers the thirteenth century. Internationally renowned Decorated or Geometric Gothic is found throughout the fourteenth century. The addition of burial transepts was an early Gothic development, with the majority of Cornish churches going through a cruciform phase. Some churches had narrow aisles in addition, and spires, of which nearly a dozen survive. In the first half of the fifteenth century, Flamboyant architecture, based on the last phase of French Gothic, was in vogue in Cornwall as elsewhere. As the fifteenth century progressed, Cornwall became wealthy from its tin industry, and trade in fish, cloth and leather hides, and much earlier building work was swept away. Most Cornish church fabric today is fifteenth- or sixteenth-century Perpendicular Gothic, characterised by upright tracery panels and a preference for granite. As late as the 1540s, most Cornish churchyards were still building sites.

Fuelled by popular piety as well as tin money, chancels and naves were actually being rebuilt in the Reformation period with stone or wooden pulpits and pews, to match the new wide aisles which housed side altars, seating and pre-mass processions. Rectors played some role, but rarely a leading one, in chancel rebuilding. By these means, most Cornish chancel arches were lost before the Reformation changed worship permanently from Catholic to Protestant. Although Cornwall with its Duchy was a Royalist area, in 1549 several clergy and laymen joined the Western or Prayer Book Rebellion when religion took too

Calvinistic a turn. Although church building work did not stop completely in the 1540s, it certainly slowed down. Lopsided plans, unfinished and tower-less churches (which acquired detached belfries from the seventeenth century on) are a major part of Cornwall's ecclesiastical legacy.

The ideal Perpendicular church, which Cornish parishioners aspired to, was three-hall in type with processional aisles as wide and tall as the nave and chancel, and triple gables at the east end. Usually these churches have a three-stage tower (two-stage in Penwith and The Lizard and four-stage in wealthier places), with set-back buttresses which draw the eye upwards. Such towers are often three times the height of the church, which can make Cornish churches look squat to modern eyes. There was no Perpendicular revival of clerestories here, in contrast to parts of Devon, Somerset and East Anglia. Round-headed granite windows without obvious tracery or cusps became the norm in Cornwall, as in the South Hams area of Devon, as frames for individual saints or stories in this latest, less exciting, phase of Gothic architecture. Such plain window frames were still being used as late as the 1660s at Falmouth.

From 1050 to 1877, Cornwall, like Devon, was part of the diocese of Exeter with some of the best late medieval church building accounts in Britain, churchwardens' accounts, workmen's contracts and many visual clues. These sources have been extensively mined here and all seven Cornish churches dated by dendrochronology are included. A wide geographical spread from the Tamar to Land's End has also been attempted here.

Photographs, unless otherwise stated, and the drawing of the St Neot fish roof bosses are the author's own work. Given the constraints of the Covid lockdowns, much use has been made of photographs in the author's possession taken by the late Peter Brierley, a professional photographer.

1. ST ALLEN – WELLS CAPITALS (8)

St Allen church has a fine early thirteenth-century, round-headed north door. With colonnettes topped by stiff leaf capitals of Early English type, the north door frame is reminiscent of Wells Cathedral. In 1269, the Valletorts of Trematon Castle, whose gatehouse fireplace has similar capitals, sold their St Allen lands to Walter Bronescombe, Bishop of Exeter.

Unusually St Allen church never went through a cruciform phase, like the majority of Cornish churches. A west tower was added to the two-cell church in the mid to late fifteenth century. Soon after this, the Bevill family of Gwarnick founded a chantry chapel on the south side of St Allen church with profits from their tinworks. Their chapel and the parishioners' south aisle doubled the size of this church, with John Bevill bequeathing 20 shillings to begin the project in 1508. In 1511, Peter Bevill, gentleman, ex-sheriff, and John's father, left £20 to St Allen chantry, an ox and cow to St Allen's store, and a cow to the guild of St Anthony. Cows were then worth 7s to 9s, or £1,000 to £1,500 today. In 1515 Peter was duly buried in his chantry where a daily mass was said by a chantry priest for his and his ancestors' souls. Statue corbels and a stone female head still survive in the chapel, as well as an earlier coffin slab rector's tomb, but the external buttresses only date from 1874. In 1517, Peter's second wife, Thomasine, left a cow to St Allen church,

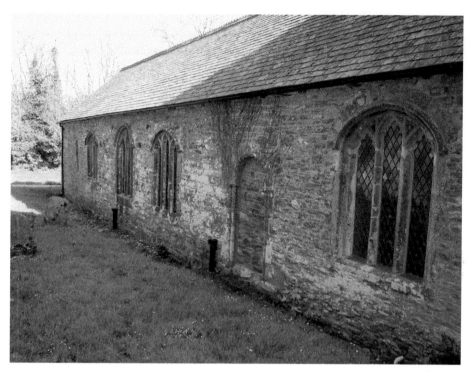

Above: St Allen. North side and door.

Below: St Allen. South side and tower with conical spirelet.

but chose to be buried in the grander new south aisle of St Mary's Truro (now part of Truro Cathedral). The Bevills had a household chapel at Gwarnick by 1378, and there was also a St Mary chapel nearby supported by a guild of St Mary. Its prayer roll survives.

2. Altarnun – Where Sheep Safely Graze (31)

A flock of sheep still graze in the south aisle of St Nonna's Altarnun on one of seventy-nine *c.* 1538–9 bench ends. With curly coats and long bushy tails, six ewes and a horned ram are shown with the rest of the flock erased by damp. On the bench end to the left a bagpiping shepherd and his dog keep watch. These sheep are the Altarnun parish flock which raised funds for the church. Usually described as a store, farm animals were given to churches in the medieval period and wealthier parishioners bore the costs of grazing and treating foot rot or murrain. Money raised from sales of fleeces, milk, mutton and lambs profited the church, and sheep kept churchyards mown. Some parish flocks survived until the Civil War, while other fundraisers at Altarnun include a crowder (fiddler) and sword dancers.

The style of these bench ends resembles the best Devon and Somerset work. Robert Daye, the carver, was probably from east Devon. His name appears on a bench end beside the late Norman font with its bearded faces. Below Daye's name are the names of Sir William Bokyngham, curate, and John Hodge, parish clerk, and a partial date MD[XXX....]. The format suggests a workman's contract, like that of 1534 for rebuilding Altarnun chancel. In this case the parties were Richard Dawe (no relation of Daye), carver of Lezant and Master John Waryn, Altarnun's vicar, then dean of Exeter, with Bokyngham as witness.

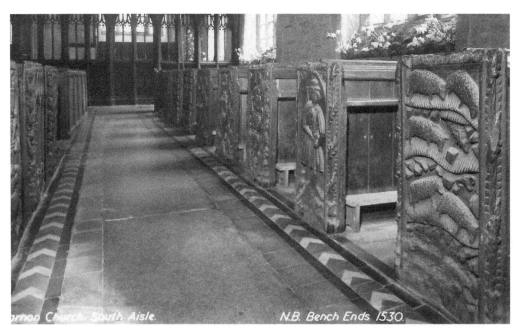

Altarnun. Postcard showing sheep bench.

Altarnun. East end matching windows.

Dawe was to make a new roof with carved roof bosses and a new four-light granite east window without cusps for the chancel like the south aisle. The agreed price was £13 6*s* 8*d* and work had to be completed in two years. Dawe received £1 every time he 'layeth his frame' at Altarnun and the vicar kept the old materials including stained glass for his own use. The north chapel dates from *c.* 1509 as its windows once featured Henry Legh esquire (*see* Lanteglos-by-Camelford).

3. St Anthony in Roseland – All-Male Sculpture Gallery (7)
Hidden away at the bottom of the Roseland, Pevsner called this cruciform church with a central tower 'the best example in Cornwall of what a parish church might have looked like in the C13'. Setting aside a fine reset late Norman south door with Agnes Dei motif, the church and its interior are pure Early English. Some of the best-preserved stiff-leaf foliage carving in Cornwall can be found around the tower crossing where a series of beautifully sculpted male heads support the corbels of the transept arches with some smaller heads higher up. This all-male sculpture gallery was new when Bishop Walter Bronescombe visited on 3 October 1259. While typical of Cornish churches of this time in a plan, the history of St Anthony in Roseland is anything but ordinary.

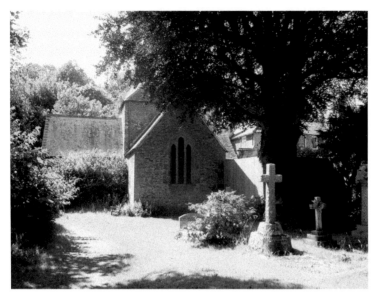

St Anthony in
Roseland. Cruciform
church with central
tower.

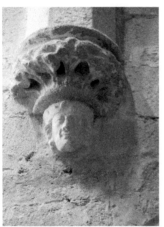
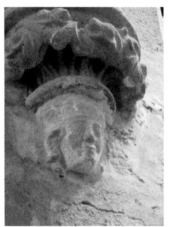
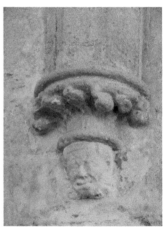

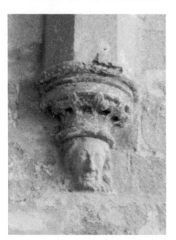

Above and left: St Anthony in Roseland. Transept arch male
corbel heads.

In the early tenth century, there was a church here dedicated to St Entenin, which soon became St Anthony. This came into the hands of the Bishop of Exeter as part of his manor with 753 acres of heathland (the original meaning of Roseland). St Anthony was gifted to Plympton Priory in the mid-twelfth century, and from then until 1539 was an Augustinian priory cell. Two early priors were buried in the chancel, the coffin of one now lying by the church path. Prior, canon and servants lived at Place House, which adjoins the north transept. In 1338, repairs were needed after a French raid, and in 1348–49, during the Black Death, the prior bought wine from a local shipwreck. An indulgence was obtained in 1435 to encourage pilgrims.

The high-ceilinged kitchen at Place still contains finely moulded Tudor beams, and there were also barns, a dovecote and two corn mills. At the dissolution of Plympton Priory in 1539, St Anthony's chancel was pulled down. As one of the poorest parishes in Cornwall with only eleven to fifteen taxpayers, it became a donative with the lord of the manor appointing the priest. In 1852 amateur architect Revd Clement Carlyon parodied the Early English style, adding a novel clerestory, new chancel, and a spire to the central tower.

4. ST AUSTELL – WARS OF THE ROSES TOWER (17)

St Austell's tower, one of Cornwall's finest, dates from the 1460s to early 1470s. Modelled on Callington's top-heavy tower, St Austell's was previously dated 1478–87 because the arms on the south-east corbel were thought to be those of Peter Courtenay, Bishop of Exeter. The arms of three torteaux, with a three-pronged label,

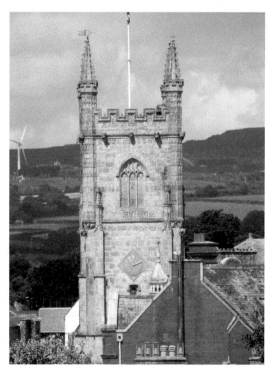

St Austell. Tower with china clay tips behind.

St Austell. Courtenay arms corbel, partly obscured by beaked beast, from Market House.

must relate to Edward Courtenay of Boconnoc, who held Treverbyn Courtenay manor in this parish. They are unlikely to date from after 1471 when Edward's father, Hugh, was killed at the Battle of Tewkesbury. A boundary stone called the Mengu stone, on the north side of the church, marks the spot where the manors of Treverbyn, Trenance, and Tewington meet. In 1485 a Vivian Trenans alias Swete set up shop in the prior of Tywardreath's new 'tin' town of St Austell and in 1507 was buried in the church. Urban status was marked by a twenty-four-hour market-regulating tower clock.

St Austell's Pentewan-stone tower may well be the work of the same masons who rebuilt Bodmin church. As well as the twelve apostles, who encircle St Austell tower, there is a complete sculpture gallery on the west face. Starting with the Trinity at the top and Annunciation below, the bottom figures are a hermit (St Mewan), a Risen Christ, and a bishop (St Austell). Mewan and Austell appear in the tenth-century Cornish saints' list and in the 1600s Nicholas Roscarrock said the two saints were friends. The Virgin Mary with loose hair from the Annunciation and tiny donor figures that flank the Risen Christ are a good match for figures on the 1471 brass of John Kingdon of Quethiock. Recut panels of Christ's Passion on the south buttresses and INRI, and a pious pelican on the porch, are early sixteenth century. Bench ends, including apostles John and Bartholomew, Passion symbols, coats of arms, tinners' tools and Reynard the fox preaching to a woman must be of similar date, like the tracery-less north chapel windows.

St Austell. Twenty-four-hour clock face.

5. BODMIN – OUTSTANDING ACCOUNTS (20)

In the middle of the eighteenth century when Mr Wallis, attorney, was examining papers at the top of St Petroc's three-storey church porch, the floor collapsed. Among the records he found was a paper account book for the rebuilding of Bodmin church in 1469–72, and a 1491 carpenter's contract for pews and pulpit. The introduction of polyphonic or multi-part music at Bodmin, with the buying of an Exeter-made organ in 1469, prompted this rebuild. Work on a south chapel, two aisles and the porch cost £268 17s 9 ½d. Richard Richowe, master mason, was contracted to choose stone at the quarries, and carve pillars and capitals. There were at least twelve other masons, half local, paid 6d a day. The Cornish building season ran from Candlemas (2 February) to All Saints' Day (1 November), and partly built walls were thatched over winter. Skilled carpenters included William Carpenter of Bideford and fellow Devonian John Sam, with local men making scaffolding for 5d a day. Seven helyers or roofers, plumbers, glaziers, stone carriers, labourers, and servants worked for 4d to 5d a day. Pentewan stone for Bodmin's south front was cliff-quarried in St Austell Bay, while local Bodiniel slate-stone was used on the less visible north side. Fine-grained granite for pillars came from the St Austell area, timber from the Glyn

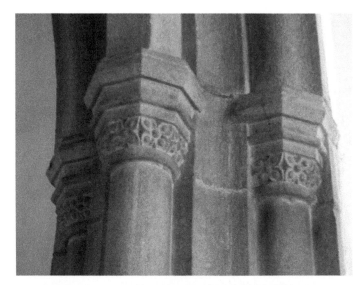

Left: Bodmin. Richowe's capitals.

Below: Bodmin. St Martin's chapel, north tower and Cornish standard perpendicular aisle windows.

or Camel valleys, lime was imported via Padstow or St Winnow, and lead came from St Ive.

At the time of the rebuilding Bodmin was the capital of Cornwall with around 2,500 inhabitants and five trade guilds of St Petroc (glovers and skinners), St Anian (shoemakers), St Dunstan and St Eloy (metal workers), St John the

Bodmin. Late fifteenth-century interior and Cornwall's most elaborate Norman font.

Baptist (drapers) and St Martin (millwrights). There were also twenty-three religious guilds as well as parish groups of young men, maidens and wives, who, with the trade guilds, raised two-thirds of building costs. Religious guilds usually had twelve to twenty-four male and female members, were often neighbourhood-based, and ensured a decent burial. A town collection lists over 460 householders, with blacksmiths giving nails. Henry Gurlyn, vicar of Bodmin, gave a year's salary, to get his coat of arms on a roof boss. Drapers – Thomas Lucombe, Bartholomew Trote, Ralf Dyer, William Olyver, Odo and Paschow Robyn and John Watte – paid to glaze St John the Baptist's chapel and south aisle, with an Ashburton man, Avery Skeys or Keys, giving ironwork for the south-west window. In 1476 Pope Sixtus IV granted an indulgence for visitors to the new St John's altar. Accounts show that building work continued into the 1480s, but left an earlier spire and Norman west end intact. The former fell in 1699 and the latter went in the 1870s.

6. CALLINGTON – MODEL TOWER (14)

When in 1450 Totnes parishioners sent overseers to look for a suitable model for their tower they viewed newly built towers at Ashburton, Buckland and Tavistock in Devon, and at St Mary's Callington in Cornwall. The unusual top-heavy second stage of Callington's 65-foot tower, where set-back buttresses become corbel-supported chunky pinnacles, was rejected as a model by Totnes, but not by Calstock, St Austell and Lanlivery in Cornwall. At Callington the corbels

are of Catacleuse stone with pairs of angels holding shields with symbols of the four Evangelists. On 2 July 1895 an early morning fire gutted Callington tower destroying bells, clock and roof. Restoration cost £1,000, including a new west window and door.

From 1377–1438, Callington battled with its mother church of South Hill to become a parish. Thanks to its Norman font baptisms were held here as well as daily masses, but on Sundays and major feasts townspeople had to attend mass and bury their dead at South Hill. An agreement was reached by papal bull in 1438 leading to the consecration of Callington cemetery and a lantern cross is likely to be from this time. South Hill still had to be visited on St Samson's day with a pair of 2lb candles and token payment of 2s, and inhabitants of Callington had to join the South Hill Ascension Day procession with banners. Nicholas Aysshton, lawyer, led the fight after he inherited Callington manor by marriage. He left £20 for the crenellated and buttressed south aisle in 1465, and his brass, with wife Margaret née Broke, is in the chancel.

A later lord of the manor and Duchy steward, Sir Robert Willoughby de Broke was buried in 1502 on the north side of the chancel under a splendid alabaster tomb. Shown with shoulder-length hair, armour, garter-chain and robes, de Broke's feet rest on a lion, and poor bedesmen (paid prayers) with hooded cloaks and rosary beads prop up his toes like two bookends. Blank shields round the base were once painted with de Broke's ship's rudder badge and coats of arms. Burial in this prestigious Easter sepulchre position ensured Broke would rise again.

Callington. Top-heavy tower.

7. CAMBORNE – JOHN HOLTON STRIKES AGAIN (34)

In 1538 when the tinners of Camborne decided to add a Lady chapel and north aisle to the Norman church of St Martin and St Meriadoc, they chose John Holton the younger as their master mason. John came from a Bodmin family of masons and was assessed on wages of £1 in the 1525 Bodmin tax list. His father, John Holton the elder, who died *c.* 1521, was one of the builders of the Berry chapel tower, Bodmin, in 1501–14. He also worked on Truro St Mary's highly carved 1504–18 south aisle, now part of Truro cathedral, and purchased timber for this work in the Tamar Valley.

The churchwardens' accounts for Camborne show that John Holton junior's 1538–43 north chapel and aisle cost over £67. Two bargains made with Holton totalled £27 and he was paid extra for making the corner of the chancel and vestry with its own piscina, casting the leads and removing a little door. As well as Holton and his servant, carpenters, a helyer (roofer), glazier, potter (who made ridge tiles known as crests) and boatmen were employed. Parishioners supplied materials including roof timbers and free labour. Lime had to be brought in by sea via Penryn or Lelant with some burnt at Tolverne kiln on the River Fal. Slate for the roofs came from Boscastle and was off-loaded at Phillack with celebratory drinks at St Ives. Mr St Aubyn, who probably gave free legal advice to the parish, received slate for Clowance house in return. Wood of sufficient width for the church doors had to be brought from Wales, while new granite windows were temporarily stopped up with reed before being glazed. Devon-style foliage capitals were used for both aisles with tracery-less windows. Worship went on meanwhile, with the Lady chapel chalice blessed in 1538. Altar cloths and a high altar canopy were given in 1543. Money was raised from parish and young men's collections and an ale or tavern, while the rector paid for the chancel and vestry. In 1543 benches are noted and, in 1549–50, the pulpit. The only bench ends to survive here are of 1617–21 date and include a harp-playing mermaid to rival Zennor's.

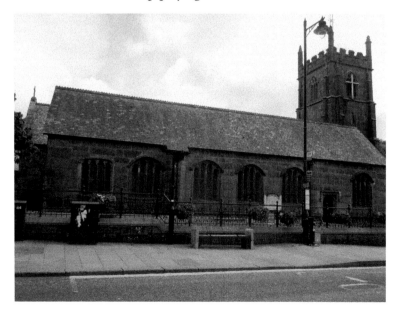

Camborne. North side.

8. St Columb Major – Earlying-up (47)

In the 1860s, St Columb Major was considered as a possible seat for the new Cornish diocese. The moated rectory in the valley below the church was rebuilt by William White as a bishop's palace, and the church underwent a major restoration. Apart from the east end and tower, much fabric at St Columb Major, including the south transept's south window, dates from the Decorated Gothic period. Ball-flower mouldings appear on the south door and the *c.* 1300 octagonal font features a man with toothache. Such was the mania for all things Exeter in the 1860s that fourteenth-century-style windows were reinstated by J. P. St Aubyn willy-nilly at St Columb Major and often where none had been in the past. The Arundell chantry on the south side was not actually founded until 1427, and probably had Flamboyant-style Catacleuse windows like Padstow before it was 'earlyed-up'. St Columb Major's St Aubyn east window was copied from St Ive, but in 1903 was replaced with a Perpendicular-Gothic design.

In 1433 Sir John Arundell, knight, of Lanherne asked to be buried in the middle of his chantry. He also left money for bells. A passageway was left under the tower because the houses of his five chantry priests blocked off the churchyard to the west. William Facy and Richard Tomyow, merchant, were buried in the north chapel of Holy Trinity in 1440 and 1484. Tomyow also gave £2 13*s* 4*d* at the latter date to Arundell's chantry, which doubled as the Lady chapel. In 1502, John Jenkyne (alias Pendyne) was buried in the churchyard before the chancel door, while Udy Engoff opted for a much more expensive chancel burial. Non-residents, Lady Katherine Arundell in 1479 and Michael Haryes in 1489, gave vestments or cloth. By 1478 there was also a Jesus chantry in the south transept founded by Sir Emanuel

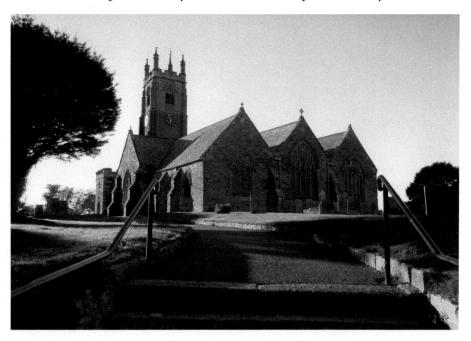

St Columb Major. East end.

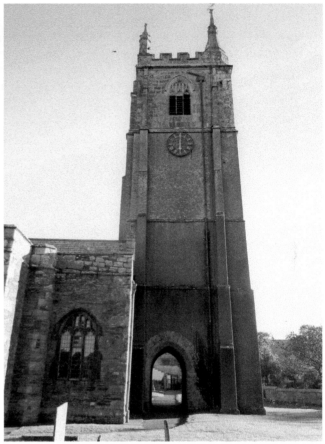

Above: St Columb Major.
Trinity chapel, early
fifteenth-century male face.

Right: St Columb Major.
Four-stage tower with
passage.

Esamus and his wife, Avyce of Tregoose, while the north housed St Nicholas's altar and possibly a statue of the female St Columb. As late as the 1580s to 1590s, Robin Hood, five morris dancers and Friar Tuck entertained annually on May Day, and the Cornish sport of hurling took place on Shrove Tuesday as it does today.

9. CORNELLY – ESTATE PEW (42)

The two-bay north chapel at St Cornelius, Cornelly, was built in 1720 over the Gregor family vault. Originally intended as an elevated family pew with fireplace and chimney, it was noted as an aisle in 1820 and thereafter called the Gregor aisle, after the family who lived at Trewarthenick south of the church. The pair of arches may date to J. P. St Aubyn's restoration of 1866. Gregor arms appear on the pulpit, and family monuments include Jane Gregor's pretty portrait bust of 1783. In 1818 it was recorded that the Cornelly communion plate was kept at Mr Gregor's house. It is possible that Sarah Gregor, née Glanville, donated the finely embroidered altar cloth in the Gregor aisle. This may be a recycled eighteenth-century pannier dress as Sarah was adept at recycling from the Trewarthenick attics. By 1825 the church was packed out with seats and until the 1860s had the usual west gallery for church musicians.

Above: Cornelly. 1720 date stone.

Left: Cornelly. Interior with Gregor pew off to the left.

Cornelly. South side with bell turret.

As a chapelry of Probus, a simple two-cell plan of chancel and nave sufficed for Cornelly's needs as late as 1722. In 1525 there were only twelve taxpayers, and nineteen in 1543. At the latter date these included a Breton named Lewis. Cornelly acquired its own parish in 1532, by which date square-headed cusped mullions had replaced most of the original lancet windows. A tiny bell turret was also added, making Cornelly one of the prettiest churches in Cornwall.

10. CREED – A SENSITIVE RESTORATION (49)

St Crida, Creed, the mother church of Grampound, remains one of Cornwall's most atmospheric churches. This was because J. P. St Aubyn's invasive 1876 plans, including a £1,800 rebuild, were rejected, and a late and sensitive restoration carried out by Otho Peter of Launceston. The Trewithen estate footed Peter's more modest bill of £700 and his restoration, completed by 1906, included jacking up the south wall, then at a dangerous angle, removing box pews, adding buttresses, preserving a rare Norman pillar piscina, stripping off the plaster from all roofs and replacing nave and chancel roofs as late medieval wagon-roofs.

Peter's lighter-touch restoration saved some of Cornwall's most fascinating stained-glass fragments. The Lady chapel windows include a sleeping soldier from a Resurrection scene, St Mary's sacred monogram (M), an eagle, the incomplete coat

Above: Creed. South aisle interior.

Left: Creed. Tregian badge in stained glass.

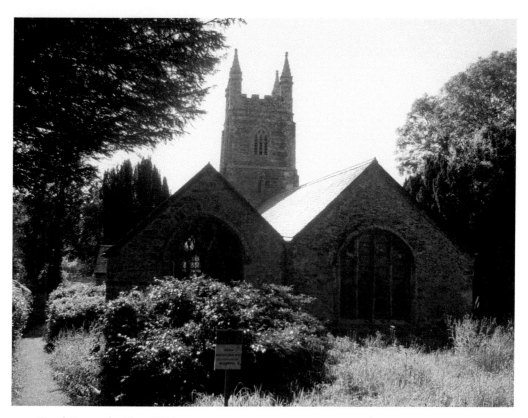

Creed. East end with *c.* 1744 tower.

of arms of Tremayne or Tregarthen, a donor, Old Testament prophet, and St James the Great. The four evangelists' symbols appear in the south aisle glazing. Of 1530s date is the tracery-less east window which once contained a crucifixion scene, as at St Winnow, a shield of Christ's five wounds and the coat of arms of the Tregian family, of Golden in Probus, featuring three jays. John Tregian esquire, descended from Truro tin merchants and became a royal servant. He was a patron of Creed church by 1533, a likely date for the window, and an intriguing diamond-shaped pane of glass of a bird with staff and chain of office by the south door may well be his badge.

None of this helps much with locating the 1451 St Mary Magdalene's altar, noted with its guild in an indulgence, though the Jesus altar, which appears in a 1546 chantry return, could have been in the south chapel. Wills refer to a fourth bell in 1448 for the original tower, and the Flamboyant rood screen base, and wayside crosses may be of similar date, too.

11. CURY – PASSAGE-SQUINT AISLE (35)

On 2 June 1543 John Skewis esquire left £40 towards the 'building of an ambulatory in the south side' of St Corentin's church, Cury. Skewis had a 'place' in this parish and was, like Tregian, a royal servant. At Skewis he left all 'manner of my books and evydences' to the use of kin and friends who would be lord and

Above: Cury. South side with transept and wheel-head cross. (Photo by Peter Brierley)

Left: Cury. Passage squint engraving by J. T. Blight.

owner after him, but no one came forward and his place fell into ruins. The general consensus is that John's south chapel project turned to ashes before it was begun, due to the abolition of processions in 1547. However, a key feature of Cury church today is a passage or walk-through squint between the south transept and chancel. Passage-squints occur in some Lizard churches and also at Quethiock in east Cornwall. By this time churches were often enlarged by building either east or west from a transept, causing minimal disruption to church services. The crude pillar that supports the south rood loft entrance is clearly a temporary prop, due to be replaced with a pier and arch once the surplus southern rood stair was demolished.

The Nanfan chapel on the north side of Cury church has early to mid-fifteenth-century inner arch carving like Padstow and Sithney. Alabaster reredos fragments of Christ and his apostles were found walled up in the northern rood stair during the Victorian over-restoration, and in 1494 a 30-foot-long 'shipwreck' timber was in Cury church store, suggesting north aisle work then.

Cury was part of Richard Earl of Cornwall's 1246 endowment of Hailes Abbey, Gloucestershire, and has a twelfth-century south door with five interlocking Olympic-style rings on its tympanum. St Corentin, Cury's patron saint – a bishop living on a fish diet like St Neot – appears with his fish in a wall painting at the mother church of Breage.

12. DULOE – BEAM-ME-UP ANGEL (22)

In the north-east corner of the chancel at Duloe, a shield-bearing angel once made eye contact with the lifelike, but now much-defaced, effigy of Sir John Colshull, knight (1416–84). Angels were soul-carriers and heavenward mobility was further enhanced because Colshull's Duloe tomb was originally under the angel, where the Easter Sepulchre ceremony of Christ's Resurrection took place. John's grandfather was a London vintner's apprentice, but when Joan Kelby, midwife, delivered John into this world in 1416 at Tremardart in Duloe, the wealthy prior of Launceston was godfather. News of John's birth was

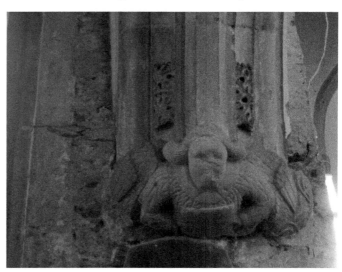

Duloe. Beam-me-up angel.

Duloe. Colshull chantry chapel and re-sited tomb (angel behind scaffolding).

carried as far as Boconnoc and Looe. By 1448 John had married a Wiltshire heiress, Elizabeth Cheyne, whose mother was a Stafford. In 1450 he was the third wealthiest man in Cornwall after John Nanfan and John Arundell (see St Columb Major). Colshull partly modelled his chantry at Duloe on the *c.* 1446 Stafford chantry at North Bradley, Wiltshire.

Duloe. North side with Colshull chapel to left and south transeptal-tower.

The Stafford arms and their knot badge appear at Duloe alongside Colshull, Cheyne and Hewis on exquisitely carved stone arches and wooden screens. A loyal servant of both Lancastrian and Yorkist kings, Colshull wears the Lancastrian collar of Esses round his neck, while the Yorkist crowned rose, Prince of Wales feather, and an upside-down grinning green man appear on the arch over the original tomb site. John Nanfan was Colshull's brother-in-law and this may be why Duloe chantry's east window has the points of its cusps enriched with cylindrical motifs with fleurons (flowers) like Cury, while the chained monkey and lion on the exterior of Colshull's chapel echo Nanfan's royal beasts at Padstow. The childless Sir John Colshull was closely involved in Duloe chapel's construction. He commissioned the Purbeck marble tomb slab and effigy, reminiscent of Derbyshire alabaster work.

Not far from the Duloe church is a prehistoric stone circle and, down the hill, the over-restored holy well. Like nearby Pelynt, this well had a font-like basin, with griffin carvings. When oxen moved the basin, insurance had to be taken out for the workmen, due to local superstition. Now in Duloe church, this basin could be the Norman font, as the present larger font is fifteenth century. Bequests to Duloe church noted in 1411 and 1509 may refer to building work.

13. EGLOSHAYLE – PULLING DOWN THE CHANCEL (30)

In the Bishop's Palace library at Exeter is the rector of St Petroc, Egloshayle's copy of a chancel demolition permit. Dated 10 July 1528, the document has a zigzag or indented top showing that there were once two copies and explains that the parish was in the process of adding a south aisle to its church. To create a symmetrical east end for travellers on the road from Bodmin, the parish wanted to rebuild the chancel to match window tracery like Padstow's east window. Eight leading parishioners added their seals to the bottom of the deed: James and Robert Castell (Kestell), Edward Hydon, John Forde, John Hambly, Robert Borrowe, William Cok and John Bluett the elder. All agreed to bear the costs of the rebuilding if the rector, Master Robert Weston, would pay for repairs, apart from gutters which remained the parishioners' responsibility. In 1522 all but two of these men provided suits of armour at the muster. Work on the south aisle, known as the Kestell aisle, probably continued into the 1530s and after a short gap a north chapel was begun in the 1540s by cutting away the east wall of the north transept and putting a pillar there from which arches could be sprung.

The rood screen and carved angels were reputedly destroyed in 1645 by Parliamentarians, but several angels survive, as well as roof bosses carved with three nails, the crown of thorns and five wounds of Christ. On the labels of the west door, Catacleuse angels carry the punning-arms of John Lovibond, rector 1461–77, and Kestell. Lovibond's arms show three hearts bound by a ribbon (love-bound). A bequest of £2 was given to the church in 1462, while 4*d* paid for a quarry licence next to Penmayn in St Minver could relate to church or bridge. Egloshayle church also has a rare early sixteenth-century stone pulpit, most others being of wood.

Egloshayle. East-end and tower. (Photo by Peter Brierley)

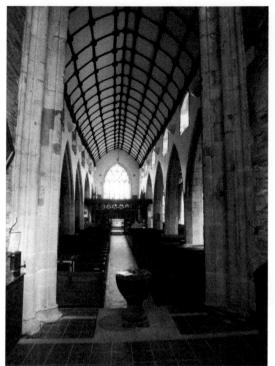
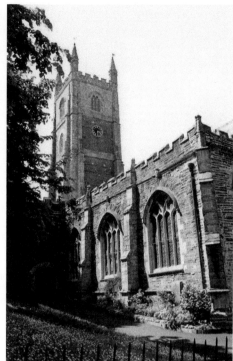

Above left: Fowey. Norman font, clerestory and dendro-dated nave roof.

Above right: Fowey. Treffry south chapel and four-stage tower.

called *The George* and *Mary Hardforth* occur in the will of Sir John Treffry, knight, in 1500, who sought burial in his newly built Lady chapel. Sir John's younger brother William set up a chantry here in 1504 and asked for a Purbeck marble tomb with brass images of himself, his brother John and John's wife. The tomb slab was recut after the Reformation with clunky images of John, William and, a third brother, Thomas. Fragments of earlier Treffry brasses of *c.* 1455 and *c.* 1476 came from a previous chapel. In 1512, William Trevanion of Caerhays Castle, nephew of the Treffrys, left 6*s* 8*d* to the store of St Barry, while in 1524, John Porth, a Londoner, paid for a trental (thirty masses) to be sung in Fowey church, where his illegitimate sister was buried. The impressive tower, with the Earl of Warwick's ragged staff badge (*see* North Hill) carved below the west window, is not mentioned in a will, but must date to the 1460s to early 1470s, as at St Austell.

16. ST GERMANS – BACK TO THE PRIORY (5)
Now called St German's Priory again, this late Norman castle-esque masterpiece was originally 165 feet long, but the 55-foot-long chancel was pulled down in 1539 when the original priory was dissolved. The Norman west front, built of greenish stone from Hurdwick near Tavistock, with its west door of seven orders

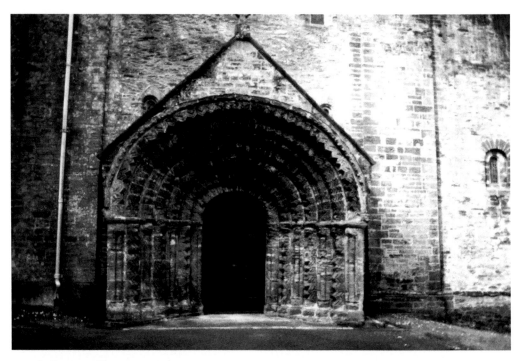

St Germans. Norman west door.

of arches, is only marred by the thirteenth-century octagonal top added to one of its twin towers. What is particularly striking is the sheer height internally. Two south-western bays still have their thick round Norman piers and blocked clerestory windows, a rare feature in Cornwall. The most easterly pillar on the north side once had a rood stair wrapped around it, and the Norman north aisle survived until 1802. Romanesque decoration ranges from scallops and spiral scrolls to crenellations and blank arches, as on the square Purbeck marble font. This font, which inspired Egloshayle's and many others, fell victim to Georgian vandalism in 1793, but in 1840 was pieced together again. One canon's stall survives from the monastic church, with a huntsman and dogs, a reminder of the rather secular lifestyles of high-up clergy.

The Augustinian prior and canons, who succeeded tenth-century bishops, allowed St Germans' parishioners to use the south aisle of their monastic church for worship. This led to a series of parish-led architectural upstagings. Exeter Cathedral masons added a Lady chapel in the early 1330s with a trio of three-light Geometric Gothic windows. Between the larger pair they placed a central image niche, a piscina to one side with a sedilia, described by Pevsner as 'especially exquisite' and an ogee-headed tomb recess with other fourteenth-century work further west. The south aisle is 6 feet wider than the canons' nave and must date between 1420 to 1455 as Bishop Edmund Lacy's arms of three spoonbill heads appear prominently on a window label. The bishop's palace was at Cuddenbeake, a few hundred yards to the south near the railway station. Other arms on south aisle labels are Scawen of Molenick (an elder tree), Arches,

Egloshayle. South chapel angel,
and three nails roof boss.

14. Falmouth, King Charles the Martyr – Cornwall's Last Gothic Church (41)

King Charles the Martyr church was begun in 1662 at the behest of a royal courtier, Sir Peter Killigrew, whose family dominated the town. It is the only church in this book built for Protestant worship from the start. Other churches with this dedication include a chapel at Peak Forest, Derbyshire, and a church at Tunbridge Wells, Kent, as well as Charles Church, Plymouth. The Killigrews were Royalists and reputedly burnt down Arwenack, their family home on the southern edge of Falmouth in 1646 to stop it from falling into Parliamentarian hands. Near to Arwenack lies Pendennis Castle which had sheltered King Charles II in 1646; the last mainland fort to surrender to the Parliamentarians. In August 1662, with £60 given from the Royal Bounty and other contributions from courtiers, land was measured out for the church and churchyard. In February 1664, a sermon was preached in the unfinished church, and it was consecrated for worship late in 1665. Sir Peter Killigrew's granddaughter Frances was baptised here on 28 February 1666. Tracery-less windows, normally dated to the 1520s–60s, adorn this, Cornwall's last truly Gothic, church.

The original King Charles the Martyr church was square with a pretty cupola, an Ionic-columned aisled interior with shades of Sir Christopher Wren, and later additions were made to both ends. Eventually attaining four stages by 1800, the cornflake-box of a tower was added with an eye to the overall urban panorama.

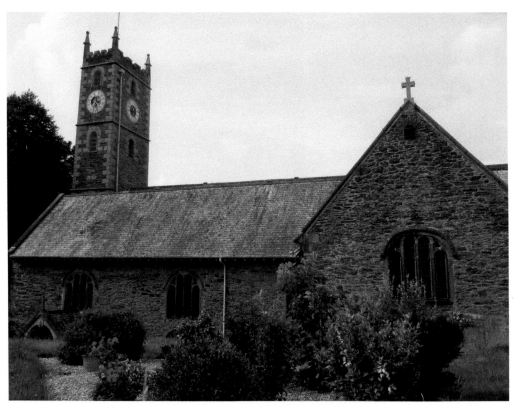

Falmouth, King Charles the Martyr. Archaic north side with later tower.

A wooden eagle lectern with its feet resting on Charles I's spiritual autobiography *Eikon Basilike* probably dates from a major refurbishment of 1759. There is also a handwritten copy of the letter penned by King Charles I to his loyal Cornish supporters in 1642 from Sudeley Castle – a Cornish church speciality – and a portrait of that king.

15. FOWEY – WOLF HALL ROOF (32)

High above the early fourteenth-century nave and chancel clerestory of St Barry's church, angels with Tudor hairstyles, some bonneted, some not, have looked down on generations of Fowey 'gallants' and du Maurier fans. There is more than a hint of the Seymours of Wolf Hall, above the rare clerestory, plotting the downfall of Anne Boleyn, perhaps? Recent dendro-dating of this roof gives a 1525 x 51 felling date range showing that it was indeed put up in the latter years of the reign of Henry VIII, involving the demolition and removal of the chancel arch. A Norman Catacleuse font with trees of life is now the earliest feature in this church.

Six wills span the period 1448 to 1524. Fowey merchant John Smyth in 1448 had ships called the *Trinity* and the *Barry*, the latter named after the church's Cornish patron, not St Finbar of Cork. These ship names recur in the 1502 will of Robert Poyle, who gave his share in the *Anne* to church building work. Vessels

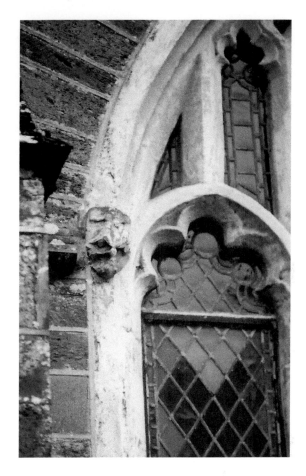

St Germans. Bishop Lacy's arms
on south window label.

and Hamley (three dogs). The large 1520s domestic-style window with Tudor-
arched priest's door below may have been paid for by the bishop's steward,
Sir Peter Edgcumbe, knight, of Cotehele, but now houses one of two Burne-Jones
windows in this church.

17. ST GLUVIAS – VICTORIAN RESTORATION ACCOUNTS (48)
Described by John Betjeman as harshly rebuilt, St Gluvias, Penryn's parish church,
has some of the most detailed and interesting Victorian restoration accounts in
Cornwall. Weekly reports of work survive at Kresen Kernow dating from 15 July
1882 to 16 June 1883 – an odd mixture of progress reports, queries and drawing
requests from architect J. P. St Aubyn. St Gluvias church had already suffered
Georgian vandalism, with ugly Y-shaped tracery and wooden small-paned
casements put in in 1744 removing much medieval tracery. Its interior was pure
Georgian, like Redruth or Falmouth with composite Classical pillars, galleries
on three sides and side vestries hugging the tower. There was even a box pew
'appropriated to a hotel' in Penryn. St Aubyn reinstated medieval-style aisles of
Ham Hill stone from Somerset, and set this dark ochre stone, which came by
train (when the line was not flooded), against much lighter walls, just as the

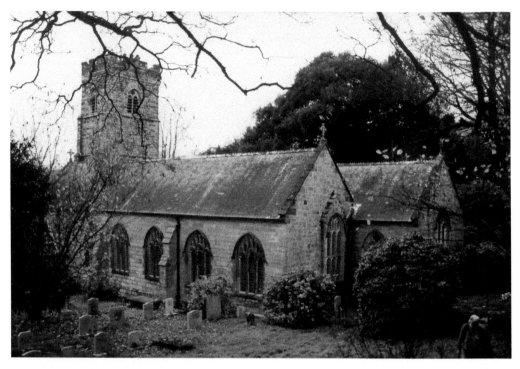

St Gluvias. (Photo by Peter Brierley)

earlier architects of Glasney College had done. Burial vaults were cleared out, a continuous wall found on the south of the nave, and stone pads under each north pillar. The foundation stone was laid on Friday 15 September 1882, seats and roofing timber came by barge and were prepared as granite plinths and gutters took shape. The south wall was restored to its medieval alignment, east gables built up and ironwork came from Mr Holman of Penzance. The old roof was taken down, as slate (probably from Aberthaw in Wales) was starting to arrive at Penryn quay. The new south porch doorway arrived in one of the last consignments of Ham Hill stone, at the same time as the heating apparatus. A stray Glasney capital was recycled in the porch.

Surprisingly, in view of the extent of restoration, the north chapel has tabernacle work and may have housed the statue of St Gluvias noted in wills of 1438 and 1511. The south chapel has a damaged panel of two haloed figures and a dove, looking like a Trinity, below the wall monument. Iconoclasts, perhaps Colonel Charles Shrubsall's Parliamentarian soldiers from Pendennis Castle in 1651, did the damage. The south chapel also housed the brass of Thomas Killigrew, gent, who died in 1501 and paid £66 13s 4d to set up a chantry here. Shown wearing a long, furred gown, Killigrew has a livery hood on his shoulder, suggesting that he may have been retained by a more illustrious gentry family. Enys family bequests also occur, including repair work, in 1511–13, while a 1549 inventory of church goods lists crimson, black, white and blue vestments. Sales of church goods paid for the new market house in Penryn.

18. GOLANT – WRITTEN IN THE ROOF (26)

In 1508, the parishioners of St Sampson's Golant were angry at demands made on them by their mother church of Tywardreath and refused to contribute to the cost of a rood loft. They had already paid Tywardreath £4 towards an aisle, £10 for bells, and glazed a window with an image of St Sampson. In a bid for parochial freedom they were enlarging Golant's two-cell church with a south aisle. The Bishop of Exeter duly consecrated Golant church in 1509, but work continued throughout the 1510s. Land was left to support an obit in 1524, with a cemetery finally allowed in 1536. Freedom from Tywardreath was celebrated by a plain octagonal font and Latin donor inscriptions on all of the wagon roof wall plates. Still in situ, these inscriptions need to be read from east to west on the south walls and west to east on the north. Four generations of Colquites with wives named Amicie, Mellicant and Celtine, and Nicholas and Joanna Hood, parents of the last, are commemorated in the south chapel and aisle. The chancel and nave were funded by John and Elizabeth Golly and the guilds of All Saints, St Eloy, St George, St James, St John the Baptist, St Katherine, and probably St Sampson. Each donor group asked visitors to pray for their souls, with the Colquites adding their merchant's mark of a mariner's astrolabe to the south chapel roof.

St Sampson's bench ends were carved by the same skilled carver as Tywardreath's, and the Colquites' astrolabe partners the twelve apostles. Towers with a king and queen's heads looking out may well represent the parents of the princess whom St George rescues. Other subjects include Veronica's veil, the five

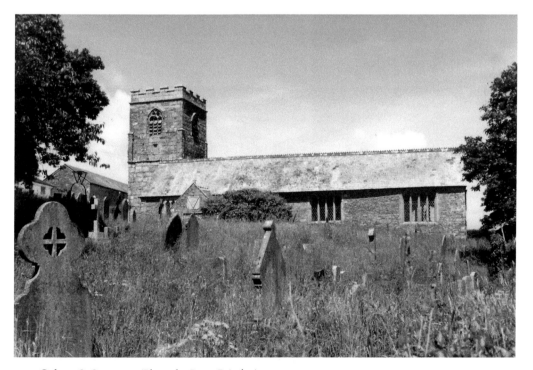

Golant, St Sampson. (Photo by Peter Brierley)

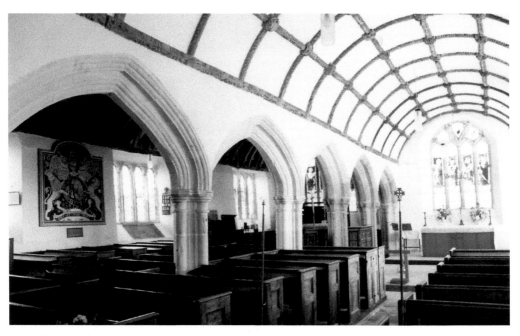

Above: Golant, St Sampson. South aisle wagon roof. (Photo by Peter Brierley)

Below: Golant, St Sampson. Bench-end pulpit. (Photo by Peter Brierley)

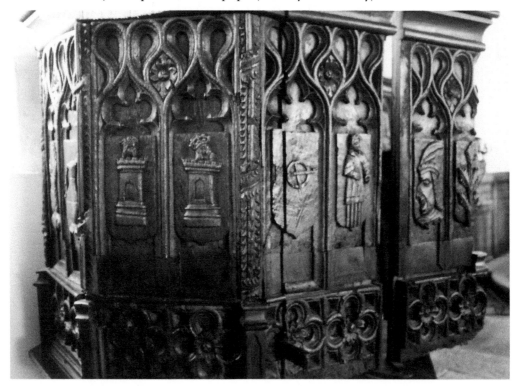

wounds of Christ, the crown of thorns, and a male jester head. A pulpit panel has a larger figure, perhaps intended for St Sampson and again badged by the Colquites. Stained-glass figures of St Anthony and St James the Great also survive.

19. ST HILARY – GOOD FRIDAY FIRE (46)

On the night of Good Friday last, a fire, occasioned, it is believed, by some casual neglect of a stove, broke out in the ancient parish church of St Hilary, about two and a half miles from Marazion. It raged with such fury as to be quite beyond the reach of any human means for extinguishing it, and only stopped short of the destruction of the tower and steeple.

Gentleman's Magazine 1853

An engraving shows the roofless church, tower and a rather taller spire. St Hilary church was rebuilt in 1853–55 with Early English originality and arch-braced roofs by the young Cornish architect William White. Finds made in the chancel foundations included the sixth to eighth-century 'Noti Noti' memorial stone. Between the two world wars this church became the setting for Anglo-Catholic

St Hilary.

ritual. Newlyn School art was installed under the direction of Father Bernard Walke, his artist wife Annie and Quaker artist Ernest Procter, until an anti-Catholic mob came in 1932 on a wrecking mission.

Late medieval St Hilary church was of three-hall type, comprising nave, chancel and aisles under continuous wagon roofs, with church fabric bequests noted in 1410 and 1487. A medieval gable cross survives. Before the fire struck, much of the church had been re-fenestrated with wooden sash windows replacing Catacleuse or Polyphant medieval tracery (*see* Paul). Carved bench ends with heraldry and symbols of Christ's Passion, a late seventeenth-century King Charles I letter (*see* Falmouth) and scripture panels were destroyed in the fire.

St Hilary's surviving tower and spire, once whitewashed as a sea mark, give an impression of what Madron's may once have looked like. Extensive views, the sub-rectangular shape of the churchyard and Roman inscribed stone could suggest a Roman military site here.

20. ST IVE – EXETER JOY (9)

St Ive has one of the best early fourteenth-century chancels in the South West. It is Exeter Cathedral-inspired and stands for the moment when Exeter was 'in the forefront of medieval [European] architecture' according to John Allan. Dating from just before 1338, St Ive's five-light east window of Beer limestone is among the most inventive Decorated Gothic window in any parish church. Its distinctive central circle is divided into six triangular forms, and flanked, internally, by

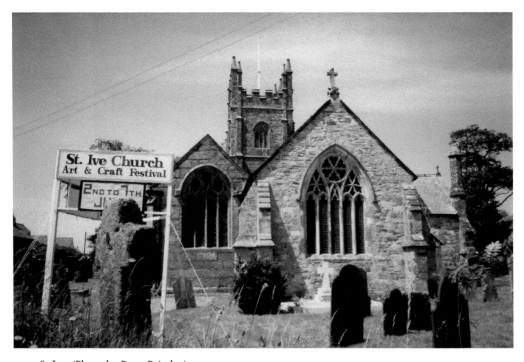

St Ive. (Photo by Peter Brierley)

nodding ogee-headed statue niches and knobbly foliage like St Germans' priory and Exeter Cathedral. Triple sedilia, a piscina and south window complete the chancel. As at Sheviock, the north transept still houses the tomb it was built to contain. Over this is a window almost as elaborate as the east window. All of this is the work of William Joy, architect of Exeter Cathedral, and the commissioner was Bishop Grandisson of Exeter's right-hand man, Bernard de Castro. De Castro was the rector of St Ive from 1314 until his death from plague in 1349. Like over 250 other Cornish and Devon parish priests (around a third of the total), de Castro died during the Black Death and was buried in St Ive church, where a few fragments of stylised drapery from his tomb survive.

From 1314, Knights Hospitallers held St Ive; a preceptor, brother, chaplain and servants living at Trebeigh in the parish. The new cult of St Anne is noted here as early as 1387, when John Keych left 29s 4d to her chapel. Unfortunately, his widow, Anastasia, spent this money on a lavish funeral for him instead. Bishop Grandisson had introduced the cult of Anne, mother of the virgin Mary, to Exeter in 1352, and her feast day on 26 July became a major one in 1381. Also of late fourteenth-century date is a beautiful alabaster statue of St Christopher, still with golden hair, probably made at Burton-on-Trent, Nottinghamshire. The buttressed south aisle, similar to Callington's, and tower are mid to late-fifteenth century.

21. St Ives – Angelic Font (13)

Built of sandrock, St Ives' many arcade piers are carved with elaborate waves not hollow chamfers between the attached shafts. These and the distinctive angel font of West Penwith type, made *c.* 1428 when baptism was allowed, mark a halfway stage in the fight for parochial rights. Four angels hold heraldic shields linked by scrolls around the font bowl, with heraldic lions below. By 1409 the town of St Ives and

St Ives. Font engraved by J. T. Blight.

St Ives. Harbour-side church.

parish of Towednack were complaining that the roads to their mother church of Lelant were mountainous, rocky and liable to flood. They asked the Bishop of Exeter to consecrate their chapels and cemeteries. Armed with a papal bull in 1410, St Ives inhabitants rebuilt their early fourteenth-century chapel larger than Lelant church. In 1434 the new church was consecrated, and the Trenwith aisle was added *c*. 1462–63 for Otto Trenwith merchant. In 1513 townspeople refused to pay mortuary (burial) fees to Lelant, and later added tracery-less windows to their north chapel. Only in 1542 was St Ives cemetery finally consecrated and this was full by 1815 when the rural dean complained that old coffins were thrown over the wall into the sea.

Surviving woodwork includes fifteenth-century roofs with repainted angels, and 1530s choir stalls with images of St Peter and St Andrew in the chancel. John Payn, the portreeve of St Ives who was hanged as a rebel leader in 1549 in St Ives marketplace, donated the latter. The choir stall front shows blacksmith's tools and may have been paid for by a trade guild of metalworkers. In 1522 no less than three Breton smiths were taxed at St Ives. The rood screen, loft and organ survived until 1647, with the pipes of the latter then reused as water pipes.

22. St Just in Penwith – Chi-Rho (1)

Not too far from Land's End is a church site that goes back to the early days of Christianity in Cornwall. Its original name Lanuste means church site of St Just. The sixth to eighth-century chi-rho stone was found in 1834 when St Just's medieval chancel was demolished. On one face is the chi-rho formed from XP, the first two letters of Christ's name in Greek, and misidentified as a bishop's crosier. One of two

Above: St Just in Penwith.

Right: St Just in Penwith. Chi-rho stone. (Photo by Peter Brierley)

chi-rhos in this parish and only five in Cornwall, on the other side Roman-style letters proclaim: 'Selus [H]ic Iacet' or 'Se[ni]lus lies here'. The church claimed to have the bones of St Just and a Norman capital survives from a possible north aisle. There was a St Just's light or store in 1426 and 1503 and a play of St Just's martyrdom may have been performed in the surviving plain-an-gwarry near the church.

Sacred monograms for Jesus and Mary appear on a mid-fifteenth-century south window label and a limestone capital from Beer in east Devon. Five raised dots around the initial J and seven around a buckle-like M on the window labels stand for the five wounds of Christ and the seven sorrows of the Virgin Mary. Murals on the north wall are of St George, the Virgin's knight, and a Warning to Sabbath Breakers. Christ shows his wounds, surrounded by tools, including a fishing boat and large fish, which inflict other wounds, the message for St Just being 'do not fish on Sundays'.

The north chapel, with Flamboyant palm pattern east window to match the south chapel, has Arwenack, Brea, and Vivian coats of arms of *c.* 1450 and acorns (like Padstow). A 1503 bequest might relate to the building of the porch which removed a south aisle window. The unsightly black grouting of the walls is the trademark of J. P. St Aubyn, the Victorian architect and, like the Marmite it resembles, people either love it or hate it.

23. ST KEW – GETTING IN A PASSION (24)

A superb Exeter-made stained-glass window of the Passion of Christ, with *c.* 1480s Middle English captions, forms the east window of St Kew's north chapel. This is contemporary with Old Testament windows at St Neot, where more conventional Latin is used. The Passion window scenes closely resemble the second day of the Cornish *Ordinalia* play cycle. Starting with the entry into Jerusalem and ending with the deposition from the cross, two other scenes, the harrowing of hell and a lost ascension of Christ, come from the third day Resurrection play. Heraldry shows that Jane, and probably Elizabeth, daughters of John and Phillipa Carminow (*see* St Winnow), paid for this window with their husbands, John Pentire junior and John Bere. Jane went on to marry Humphrey Calwoodley of Helland, who was implicated in the 1497 Perkin Warbeck rebellion and forfeited his land. Rebellion ran in the family as Jane's grandson, Humphrey Arundell, was one of the rebel leaders executed in 1549.

Startlingly three-dimensional and using the brightest colours then available, the ten surviving Exeter-made scenes are like alabaster panels. An archaic tunic with oak leaf edges and the Last Supper's loaves and fishes are among many details that delight. Two smaller Nativity scenes from a Life of the Virgin Mary, part of a five wounds of Christ badge (upside down in the middle tracery light), and oversize family donor groups with Latin inscriptions clearly do not belong here. In the south chapel at St Kew is part of an early fifteenth-century Jesse window. Christ's family tree is an unusual subject for a parish church, and this one may well have been bought second-hand in 1470 from Bodmin. The Virgin Mary and Jesse wear matching red costumes with gold fleurs de lys for him and gold flowers for her (*see* St Winnow). Other St Kew glass, once in the north aisle, includes the arms of Edmund Arundell, knight, brother of John Bishop of Exeter, who held Hendre in St Kew until 1504.

Above left: St Kew. Passion window.

Above right: St Kew. Harrowing of Hell scene.

Below: St Kew. (Photo by Peter Brierley)

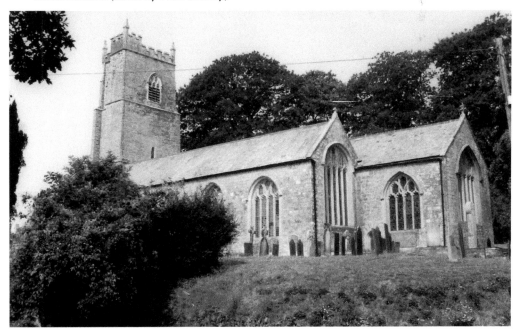

St Kew also has an early Christian sixth-century memorial stone which uses the Irish linear alphabet known as ogham. It also has an exceptionally long chancel, a tower stair on the south side, a lantern cross-head and original church door. The lower half of a finely carved fifteenth-century limestone statue of St John the Baptist shows his camel skin costume including camel head.

24. LANSALLOS – PHOENIX RISING (33)

With bells vandalised by drunken villagers in the early nineteenth century, lightning strikes in 1923 and 1975, bomb damage in 1941, an organ fire in 1949 and arson attack in 2005, St Ildierna's church has become used to resurrecting itself. Perhaps surprisingly, Lansallos still has all its original late medieval roofs; and dendro-dating in 2005 revealed that, like many other Cornish churches, Lansallos was still a building site in the 1540s. Church enlargement had begun here around the 1490s with the south aisle, and one nave roof timber had a precise felling-date of 1514. In the 1520s–30s a south porch was added to the south aisle, and the north chapel, which never became a full aisle, must date from around 1540. Of the same date are the chancel and the rest of the nave roof, all after Henry VIII's break with Rome. Dendro-dating suggests at least four phases of building work at Lansallos and no fewer than three dendro-dating phases have been identified for the pews.

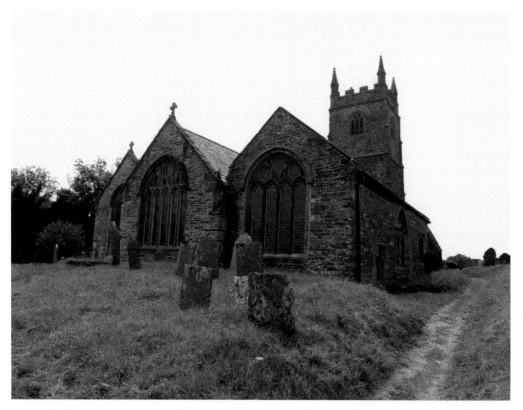

Lansallos.

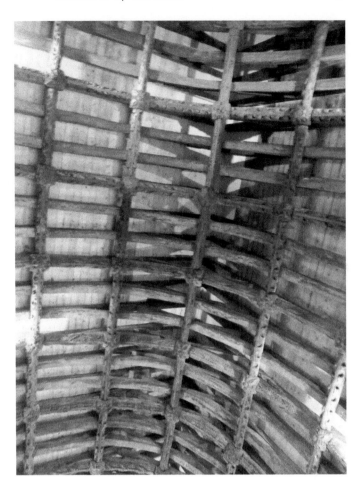

Lansallos. North
wagon roof.

These are no earlier than *c.* 1520, with Renaissance-style bench ends mid-1530s
to 1550s.

The work of skilled carvers can be seen all over Lansallos church. Tomb
fragments of armed knights and their wives – the Hewis family of Rathwell manor
in this parish – probably date from the 1300s or later and came from former
transepts (*see* Sheviock). The tower has a curious bearded man with stumpy arms
supporting a statue corbel and ogee-arch, with flamboyant motifs and quatrefoils
around the tower's lichened buttresses. Internally carvings include a splendid
green man tower corbel, two Norman-style fonts, Tudor rose roof bosses, and
granite monolith piers with Devon-style foliage capitals, as well as the bench ends.
Here, too, can be seen the coffin-shaped slate tombstone of Margery Budockside
(née Smith) carved in 1579 by Peter Crocker of Looe (*see* St Martin-by-Looe).

25. Lanteglos-by-Camelford – Unusual Sophistication (23)
The surviving south window tracery light glazing at St Julitta's has been described
as unusually sophisticated. It includes the Apostles' Creed, four evangelist symbols
and two Old Testament priests. Each priest has a small female attendant wearing

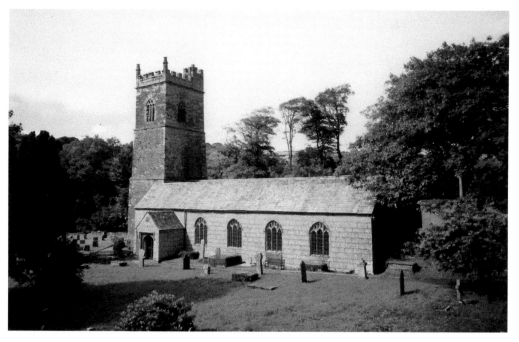

Lanteglos-by-Camelford. (Photo by Peter Brierley)

a dress with the crowned buckle-like M badge of the Virgin Mary. Inscriptions identify these as Solomon and Salome, and Joachim and Joanna. These priests served the Jerusalem temple while Mary Salome, a step-sister of the Virgin Mary, with Joanna, was one of the witnesses of the Resurrection. The south aisle felling date range of 1469 x 91 suggests this glazing was done when John Morton was rector of Lanteglos and John Penfound esquire of Poundstock, the Duchy parker of Lanteglos and Helsbury (their dates being respectively 1466–88 and 1465–85). The two men acted together to sort out a parochial land dispute, and the Morton coat of arms of a goat's head erased quartered with five ermine spots set against the Yorkist sunburst badge appears in a north chancel window. This south side of the church was used by the town of Camelford, the Bodulgate family and their Roscarrock, Coryton and Trenowith descendants.

Lanteglos was a Duchy of Cornwall church and Helstone in Trigg manor in the parish supplied a grey cloak to the Duke whenever he crossed the Tamar. In 1485–1509 the Duchy parker was Henry Ley esquire, of Bere Ferrers in Devon, and his period of office overlaps with the 1489–1511 rectorship of Thomas Morton. Dendro dates for the north transept and nave roofs are 1483 x 1508 and 1485 x 1510, respectively. Henry Ley fought for Henry VII at the Battle of Bosworth and died in 1509 in this parish at Helsbury Park New Lodge. The north transept became the Ley chantry with Henry formerly shown here in stained glass. He is described as wearing armour, with a helmet and prayer desk, and behind him knelt his wife, three sons and four daughters. The unusual Flamboyant-style chancel east window has had its central motif replaced often, in both wood and plaster, but similar motifs can be found on the font.

26. LAUNCELLS – AS THE LATE GEORGIANS LEFT IT (43)

Whitewash, that Georgian cover-all, was even applied to the 1624 wall monument of Sir John Chamond and the large plaster royal coat of arms of Charles I. With the best Georgian interior of any in Cornwall, St Swithin's Launcells' present appearance may be a legacy of Sir John Call of Whiteford who liked to claim descent from three Saxon brothers who came into Britain around 820 and settled in Norfolk, Scotland and the West Country. In fact, Call was a yeoman's son linked to Prestacott, Launcells, who made a fortune as Robert Clive's engineer in India. Call came back to Cornwall in 1765, seated himself at Whiteford in Stoke Climsland parish and built a new house at Launcells Barton in 1771 for his sister. This house became the vicarage and the seat of the Jones family, and Call paid for a marble reredos in the church in the latest Georgian Gothick style. Brick repairs

Launcells. Interior with
whitewashed tomb.
(Photo by Peter Brierley)

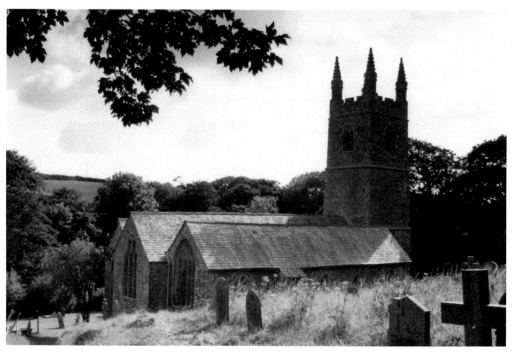

Launcells. (Photo by Peter Brierley)

to the east window and additions to pulpit and tester (sounding board over pulpit) occurred at this time. A west gallery for singers was put in as early as 1766, and box pews (now only in the north aisle) were built over and around Tudor bench ends. Nave and chancel are indistinguishable in one long tunnel of plaster. Also Georgian are four bells cast at Gloucester in 1751 and brought to Bude by ship.

Yet, if layers of whitewash are peeled back, one finds an early Norman tub font, a handsome airy Gothic church of unexpected height with Polyphant piers in the south aisle, Tudor bench ends with shorthand motifs like the gardener's shovel and St Mary Magdalene's ointment pot for 'Noli me Tangere', and possibly bits of the rood screen. Furnishings from Chamond's time include early seventeenth-century Barnstaple heraldic tiles, for the chancel with griffins and Tudor roses, a pretty wooden font cover, and a mural of Abraham and Isaac which covers the south-west wall. In 1628, Sir John Chamond's son Richard stored his velvet saddles and spinning wheel in the upper room of a church house in the churchyard where fundraising Whitsun ales and feasts had once been held.

27. LAUNCESTON, ST MARY MAGDALENE – FAIR ISLE JUMPER IN GRANITE (27)

The tale of a misaligned birth horoscope, accidental bathtub drowning of the male heir, abandonment of a great mansion *c*. 1540, and funds invested instead in this extraordinary fair isle jumper church can only be traced back 200 years. Like most good folk tales there is a grain of truth in the story. Henry Trecarrell esquire

and his wife, Margaret Kelway, of Trecarrell in Lezant parish were only survived by four daughters, born between 1497 and 1520. The youngest, Lora, brought disgrace on the family in 1535 by eloping with Oliver Kelly, a Devon gentleman, while on her way to this church. Trecarrell accused Kelly of rape, while swiftly marrying a pregnant Lora off to John Trelawny of Pelynt.

Henry Trecarrell played an active part in Launceston life and was mayor there. In 1506 he and Margaret built a St Mary Magdalene chapel at Trecarrell and from 1511 to 1544 shovelled money into the building of its Launceston namesake. Their arms appear on the porch above a scroll bearing the date 1511 in Roman numerals and in many other places. The south aisle was begun by 1513 and in 1521–22 the church was covered with 34,000 slates and 96 feet of ridge crests.

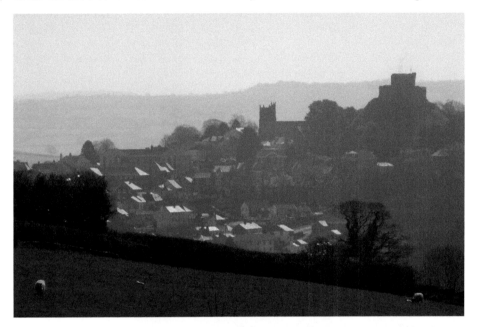

Above: Launceston, St Mary Magdalene. Town church and castle.

Right: Launceston, St Mary Magdalene. Porch date scroll with Kelway and Trecarrell arms above.

On 18 June 1524 the east end was consecrated for worship, an oak tree was given in 1532, and in 1538 plumber William Morys of Modbury, Devon, was contracted for the gutters and leads. Finally, in 1543–44 Sir John Arundell, knight, gave £3 to glaze the east window. During this time, the Trecarrells created an estate and house to rival Cotehele, home of Piers Edgcumbe, knight, then Launceston's recorder. Only the great hall and entrance arch of Trecarrell manor were finished when Henry Trecarrell died in 1544.

Launceston St Mary Magdalene is unique in its decoration and the sheer madness of carving granite. Space was left for a grander tower, but this was never built. South porch imagery includes St George fighting the dragon, St Martin splitting his cloak for a beggar, a windmill, Magdalene's ointment plants, and the Prince of Wales' feathers. A Latin inscription in praise of the Virgin Mary begins at the priest's door and wraps around the base plinth to the north door with its extinguished torch. At the east end, under the royal arms of Henry VIII, twenty musicians (noted in a 1440 indulgence) still play for St Mary Magdalene, who is shown as a Good Friday penitent creeping to the cross.

Launceston, St Mary Magdalene. West wall.

28. LISKEARD – MURDER MOST FOUL (21)

On 27 August 1472 at 4 a.m., John Glynn of Morval, royal commissioner, was brutally murdered on his way to Tavistock fair by Thomas Clemens of Liskeard and six other men. This was part of a lawyers' feud which began in 1468, when Glynn took the post of deputy-steward of the Duchy of Cornwall away from Clemens and imprisoned him. Clemens continued to feud with Glynn's young heir, while in 1477 witnessing an agreement to add a north chapel to the chancel of St Martin's church, Liskeard. Perhaps in a bid for atonement, this became Clemens' chantry. The north side of Liskeard church has impressive battlements and an array of projecting altar bays and north porch with stone vaults. Endowed with lands worth £7 9s 7d per year, Clemens' chantry priest held a daily mass and prayed for the murderer's soul. In 1543 Thomas Devyrell was the chantry priest

Liskeard.
North aisle and
Clemens chapel.

and received a salary of £6 6s 1d with 10s paid to other priests and clerks singing anthems in the church, and the chantry had its own chalice and vestments. In 2018 bones of eighteenth- or nineteenth-century Liskeard inhabitants were found immediately under the Victorian floor, as at Sithney.

Much earlier, around AD 1000, Duchess Ethelfleda freed a female slave here. From the twelfth century on Launceston's prior was rector and the priory arms, a red cockerel on a silver background, was in Liskeard's chancel window as late as 1644 and on benches. In 1400–01, Liskeard, Linkinhorne and Talland parishioners had to petition parliament and Master John Waryn, Liskeard's vicar, visited Rome to prevent Liskeard's demotion from a vicarage to curacy. Relations with the priory had improved by 1428–30, with Liskeard parishioners allowed to knock holes in the prior's chancel wall to extend their church southwards. An outer south aisle was added in the 1490s–1500s by the same masons as St Neot, according to Peter Beacham. Maltese crosses were carved around the outside, where the Bishop of Exeter had anointed Liskeard church walls with holy water or oil, when re-consecrating the church.

Twin Norman west towers, like St Germans, with muzzled bear and other corbels survived until 1627, with the present tower dating from 1902.

Liskeard. 1902 tower and north aisle.

29. ST MABYN – ROOD SIGNPOSTING (28)

The clustered capitals of the first north aisle pillar include the letters INRI, for Jesus of Nazareth, King of the Jews, signposting the crucifix or rood over the screen to the east. The north-aisle roof appears to be from the 1520s according to dendro-dating and this neatly coincides with the rectorship of Master Oliver Pole (1515–34). The rector's initials, a capital O and a reversed P, appear three times on the INRI capitals. Pole was Oxford educated, archdeacon of Lewes in Suffolk in 1516–20, and close to the early court of Henry VIII and the Duke of Suffolk. Indeed, Pole's patrons at St Mabyn included Humfrey Wyngfield esquire, general attorney of the Duke, who had an interest in the manor of Trevisquite in this parish. St Mabyn was a wealthy and highly desirable living worth £36 a year in 1534 with Pole's predecessor being Bernard Oldham, the Bishop of Exeter's brother. A chancel pillar, east of the INRI one, has a repeating pattern of H's, perhaps a compressed version of IHS, Christ's sacred monogram. Rebuilding at St Mabyn began with its unbuttressed tower with carved beasts and the arms of Alice (née Carburra) and her son Thomas Luccombe, who was alive in 1491. The nave was remodelled in the 1500s with the near contemporary south aisle failing to date and the porch having a wider than usual felling date range of 1487 x 1523.

St Mabena was reputedly one of the twenty-four children of Brychan, a group of missionary saints whose origins lie in Welsh literary legend. Hartland Abbey reinvented the legend using the dedications of north Devon and Cornish churches whose patronage they wished to acquire. Nicholas Roscarrock in the early seventeenth century noted a song or hymn sung of St Mabena when the church was 'new builded' around 1500, signifying that she had twenty-three brothers and sisters and a feast day on 18 November. A much-restored 1528 image of St Mabena appears in a St Neot stained-glass window.

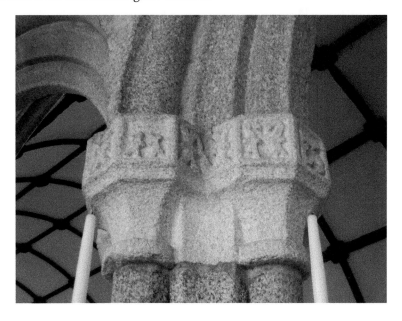

St Mabyn. INRI capitals.

St Mabyn. Hilltop site.

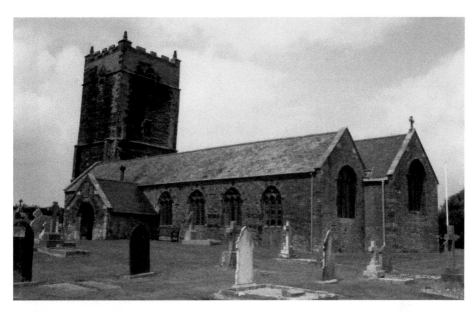

St Merryn. (Photo by Peter Brierley)

Catacleuse, a fine-grained blue-black stone, came from a small coastal quarry near Harlyn in St Merryn parish, not St Columb Major. Used for fine carving from the Norman period on, blue-grey Catacleuse was later used for the seven-bay south arcade at St Merryn, and twelve-apostles' fonts at St Constantine chapel in this parish (now St Merryn's font) and Padstow. St Merryn's south

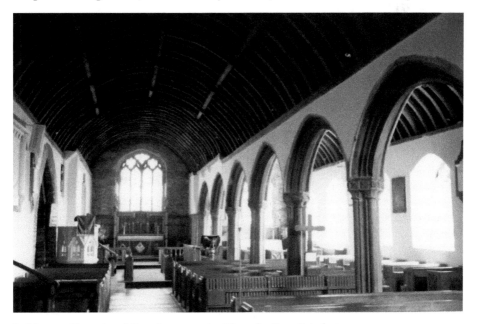

St Merryn. Chancel and Catacleuse arcade. (Photo by Peter Brierley)

arcade removed two of the 1422 chancel windows, with one recycled as the south-east window. The carving of the Devon-style capitals here with foliage and floral motifs is crisper than granite and probably dates from after 1500, the aisle being as wide as the nave.

33. MORWENSTOW – PLAYING CATCH-UP (37)

St Morwenna's, Morwenstow, is Cornwall's most northerly parish and lies far away from the main areas of granite quarrying. In 1564, Morwenstow played catch-up and built a granite south aisle, but no south or north chapel. The inscriptions round two capitals of the aisle reads: 'This was madeth AD MVCLX4' and 'This is the house of the L[ord]' and the mason went on to make Kilkhampton's 'Port Celi' (gateway to heaven) porch in 1567. The lateness of this aisle was due in part to the fact that Morwenstow's tower was still being built as late as 1549, when £6 was lent to finish it. Pews were first introduced in 1573, according to an inscription along the rail, much later than usual in Cornwall.

By contrast, on the north side of Morwenstow church there is one of Cornwall's most elaborate Norman aisles with scalloped capitals, beak-head and chevron decoration. This early aisle has north Devon parallels linked to the re-founding in 1169 of Hartland Abbey. With a tub font of *c.* 1100 and a mid-twelfth-century south door paid for by Robert of Gloucester, King Henry I's bastard brother (whose castle was at Kilkhampton), Morwenstow's north aisle is actually the third phase of Norman work here. Widened and heightened in the sixteenth century,

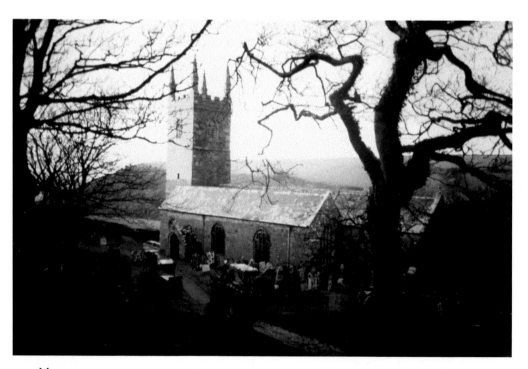

Morwenstow.

North Hill. Royal marriage wall plate and residual chapel arch support.

North Hill. South show aisle.

and their successors at Trebartha. Compared by Peter Beacham to St Neot and Liskeard, the buttresses and pinnacles at North Hill are closest to St Mary Magdalene, Launceston and must date from the 1510s to 1520s. Up to 1548 an obit was funded by the rent from a Liskeard garden.

37. NORTH PETHERWIN – NORMAN SURVIVALS (6)

For most of its history this well-documented church lay in Devon. Once part of a Cornish estate extending to South Petherwin before Launceston existed, St Patern's, North Petherwin, has a *c.* 1200s north aisle with round Norman scalloped capital piers and pointed transitional arches above. The clerestory windows are *c.* 1300 and a rarity in Cornwall with only Callington, Fowey, St Germans and Lostwithiel still having some. What is extraordinary at North Petherwin is the sight of a single very high granite arcade gobbling up the Norman aisle and clerestory. An awkward north aisle building break marks the end of the 1518–24 north chapel building campaign, with the south chapel completed 1496–79 and south aisle built in 1505–10. The Norman font (*see* Altarnun) was broken in 1495–96 during building work and replaced with a crude granite octagonal bowl.

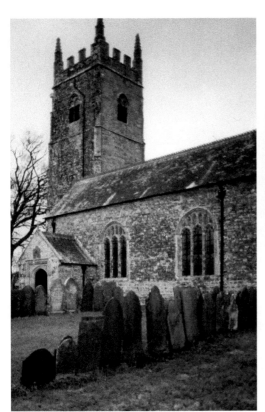

Above left: North Petherwin.

Above right: North Petherwin. Lean-to aisle and clerestory of Norman and later date.

Unusually good building accounts confirm that a major change in granite supply took place in Cornwall in the mid-1500s as noted in the 1501–14 building accounts for Berry Tower, Bodmin. The finer-grained granites of Hingston Down, near Callington, were abandoned in 1507 for cheaper and coarser Rough Tor granite from Bodmin Moor. This explains the colour change in the south aisle pillars from white to brown. Trackways were made across Bodmin Moor for transporting granite, while the River Tamar as far as Morwellham, Devon, was used to bring lead, and wainscot panels for the rood screen and loft from Plymouth. Other timber came from Penfound in Poundstock parish and Hatherleigh in Devon, and craftsmen, mostly named, came from Cornwall, Devon and Brittany. Ten guilds and two parish stores paid for two-thirds of the work, as at Bodmin, and guild members feasted on meat, bread and cheese or fish, potage, peas and mustard depending on the season. Gaps of seven to ten years between major building projects allowed North Petherwin parish to recover and re-energise its competitive guild-centred fundraising. In the final phase, Breton carvers led by Peter Papyas made a new rood screen and loft, the base of which survives, but it is Roger Longe's grotesque heads and dragons along the north chapel wall plates that charm most today.

Measuring or circling the church with a year's supply of candlewick is noted here in the 1490s churchwardens' accounts. After the ceremony the wick would be cut up and tapers and candles made to burn before the rood, Easter sepulchre, and images of All Hallows, St Christopher, St George, St John, St Luke, St Michael, St Nicholas, Our Lady, St Patern, St Thomas, and the Trinity.

38. PADSTOW – ROYAL BEASTS (15)

On the outside of the south chapel of St Petroc's, Padstow, are two headless beasts carved in stone. The one on the right has the mane of a lion, while that on the left represents a horned yale (a mythical beast) with a crown collar, chain and hooves. These are the royal beasts of Henry VI and the chapel was put up by his loyal servant, John Nanfan of Tregerryn, in Padstow and Birtsmorton in Worcestershire. Nanfan's coat of arms of a chevron between three wings appears impaled with three Penpons wolves on a shield held by a boy between the beasts. These visual references speak of the illustrious career of a Cury boy who became an esquire of the body to Henry VI, governor of the Channel Islands, keeper of Cardiff Castle, and sheriff and Justice of the Peace in Cornwall. Nanfan's chapel was probably begun after he made his will in 1446 and finished before his death around 1459 with palm pattern Flamboyant-style windows, like St Just in Penwith. Inner arch decorations, like the chantries at Cury and Sithney, extend across the whole east end here and might relate to the church receiving an indulgence in 1440. East and north-east windows from this scheme were replaced in the 1520s–30s

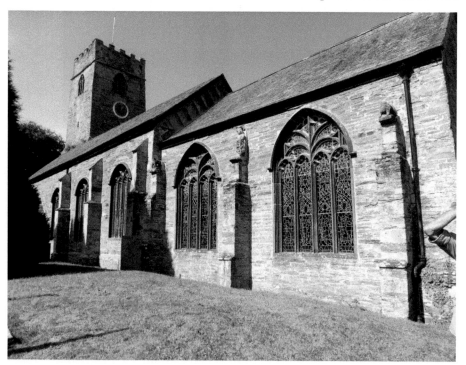

Padstow. Nanfan chapel, south aisle and tower.

with Egloshayle-style windows. A brass indent, now forming the bottom step of Padstow's north door, might be part of Nanfan's lost tomb. There is also a Catacleuse font with angels and the twelve apostles and a 1530s oak pulpit.

Other beasts include Reynard the fox, who still preaches to geese from a pulpit on a bench end. The chancel piscina includes a cowled figure of St Petroc, with the stag the saint rescued from huntsmen at his feet. The Padstow Obby Oss, no doubt originating as a pre-Reformation fundraiser, still dances through the town's streets every May Day.

Padstow was always an important church with eighth-century cist graves found outside the present churchyard, a huge churchyard cross base, and probably a spire originally.

39. PAUL – BURNING BELLS (38)

According to a port book in the National Archives, on 23 April 1595 St Paul's three church bells were sent to Bristol on *Le John* of Mousehole. On 30 June carts took the recast bells the mile uphill from Mousehole quay to Paul church where feasting and drinking celebrated their return. Bells were a symbol of parish pride, calling parishioners to church, wealthier inhabitants to their graves and warding off thunderstorms.

Paul. Tower engraving by J. T. Blight.

Paul. East end with sash window.

Then, less than a month later, on 23 July 1595, Mousehole and its neighbours were attacked and burnt by a Brittany-based Spanish raiding party. These invaders called this Protestant church a mosque and burnt it, too. Only Paul's tower, built around 1469 with a fleur de lys corbel for a statue of the Virgin Mary, survived. In 1608 Richard Denys left £2 to the 'casting anew of the bells'. These bells were replaced in turn in 1727 by a set with the slogans: 'Prosperity to this parish', 'Prosperity to the Church of England' and 'To the church the living call and to the grave to summon all'.

At the time of the raid, Paul church housed a May Day hobbyhorse which the Spanish described as an idol and burnt. The parish register starts with the names of three men killed by the Spaniards and buried at Paul, notably Jenkin Keigwin whose Mousehole home is one of only three buildings that miraculously survived the raid. Poignantly, the roofless fifteenth-century church was the scene on Sunday 28 February 1596 of the baptism of twenty-year-old Alexander the Moor, the black servant of Thomas Chiverton of Kerris in Paul parish. Chiverton died in 1604 leaving £13 6s 8d to rebuild Paul church with plainer octagonal granite piers. In 1608 Nicholas Boson of Newlyn lent money to buy lead for roofs as well as supporting the tower fund. Boson's descendants helped keep Cornish alive and Dolly Pentreath, one of the last speakers, was buried here in 1771.

St Martin-by-Looe. Interior with Pinwill work. (Photo by Peter Brierley)

32. St Merryn – Catacleuse on the Doorstep (12)

Most Cornish chancels were rebuilt and extended eastward in the thirteenth or fourteenth centuries as ritual ceremony increased. At St Merryn this was delayed until 1422. An account, unusually in English rather than Latin, survives amongst the records of the dean and chapter of Exeter. Master Benedict Drew, dean of Exeter and rector of St Merryn, paid for the work and John Tresythny, tithe collector (and in 1433 executor of Sir John Arundell, knight's, will), was associated. Taking down the old chancel walls cost 10s and an unnamed mason was paid to make the walls anew with one window on the north and two on the south side of the chancel costing £10, and an additional £2 was paid for the Catacleuse east window. This was brought from St Columb Major (perhaps because there were skilled masons working there for the Arundells), with transport costing 2s. Timber and carpentry work for St Merryn chancel came to £7 and ironwork for all four windows cost £1 14s 4½d with 6d spent on lead. Chalk and resin for the windows cost 2s 6d, and 1d, respectively, and 55 feet of glazing was 1d a foot. The chancel piscina and plastering came to 10s, the high altar ceiling cost another 26s 8d, and 2s was paid for unspecified stone in the chancel. Wooden centerings used to form window arches were bought for 5s, with 4s and 2s 2d spent on scaffolding and posts. The final payment was £3 10s for tiles (slates) to roof the chancel, bringing the total cost to £30 8s 7½d.

St Martin-by-Looe. South side with Looe transept.

St Martin's. The town of East Looe had always claimed half the seats in St Martin's church and this extra transept allowed them to move out of the nave and occupy the south side. Later, in an inspired move, between 1923 and 1948 Violet Pinwill was employed by rectors William and Martin Picken. Violet carved new seating and a rood screen which showed such un-medieval subjects as women's work and a blacksmith's shop where swords are turned into plough shares and spears into pruning hooks.

With a re-sited Norman north door, like most Cornish churches St Martin's went through a cruciform phase in the thirteenth to fourteenth centuries. A tombstone survives from this period and the tower is likely to date from *c.* 1400. In the 1470s to 1480s a new chancel roof, Lady chapel and south aisle were built. Only the last two Cornish standard piers of the south aisle are of granite, which *c.* 1500 was the material of choice. Creation of a matching north aisle involved re-roofing and turning round the north transept between 1490 and 1505, but for some reason this project stalled. The south side was then re-fenestrated with square-headed cusped mullions; Walter Kyngdon, rector, in 1515 left money for this purpose. Installation of a new rood screen in the 1520s–30s, as elsewhere, led to the removal of the chancel arch, re-roofing of the rest of the chancel took place in the 1520s to 1530s, and a new nave roof followed in the 1540s–50s.

Outstanding church monuments include the 1590s slate relief tomb of Philip Mayow, an East Looe gentleman, carved by Peter Crocker of Looe (*see* Lansallos). Fenced in in 1612 with a painted screen, an old-fashioned 1676 wall monument, of Walter Langdon esquire and his wife Rhoda of Keveral in this parish, now graces the former Lady chapel.

Madron.

Mother church to Penzance, Madron was under the patronage of Templars and then Hospitallers who chose the priest, and so has quality fourteenth-century features in Devon Beer limestone. It is possible that Madron once had a spire, replaced with a clumsy corbelled-out second stage before 1540. Madron's aisles have wave-moulded piers, and wooden roof angels, as at St Ives. The early to mid-fifteenth-century rood screen is like one at Dunster, Somerset, and Elizabeth I's coat of arms in oak, which replaced the rood, is an unusual survival. Sculpture includes sixth- to eighth-century pillar stone memorials from the earlier churchyard of Landithy, Norman corbel heads, and a late medieval coloured-alabaster altar reredos panel of the nine orders of angels.

31. ST MARTIN-BY-LOOE – LOOE TRANSEPT (39)

While Diocesan Advisory Committees today agonise over where to put a toilet, St Martin's simply added a Looe transept, East Looe being 1½ miles south of the church. St Martin's is one of Cornwall's few churches fully dated by dendro-dating, all of its roofs proving to be later than previously thought. The south transept or Looe aisle, originally thought to date from just after the late fifteenth century, has timbers with a felling date range of 1591 x 1616. It probably dates from the early 1600s as a seating agreement was made on 17 November 1599 between East Looe and

There is a stone pulpit panel here and a Norman font like Egloshayle, while angel heads survive in tracery lights. As late as 1620, St Mabyn had a sheep store run by a young men's group.

30. MADRON – BORLASE-BLIGHT REPAIRED (45)

In the early 1870s Revd G. W. Phillips visited St Madern's and other Cornish churches with his camera and his remarkable photograph album is at Kresen Kernow. His Madron view shows the south side of the church with only two wooden sixteen-paned sash windows and the original simpler porch. All other windows appear to be filled with medieval stone tracery, but surviving churchwardens' accounts and Henry Pendarves Tremenheere illustrations of the 1800s at the Royal Institution of Cornwall show this to be illusory. All of Madron's seventeen main windows had lost their medieval tracery by 1772–73 and wooden frames for more than 414 panes of glass were painted by Penzance painters Coulson, Vinnicombe and Scaddan. This was all done to lighten the church and the elderly vicar, Dr Walter Borlase of Castle Horneck, brother of William Borlase, the antiquarian vicar of Ludgvan, was responsible. Replacement of Madron's wooden windows with guesswork stone medieval tracery, and a resultant darkening of the interior, began as early as the 1840s. Three different attempts were made to get Madron's chancel east window right between 1842 and 1894 culminating in a pseudo-fourteenth-century window to match the solitary surviving sedilia.

With the best collection of eighteenth- and early nineteenth-century funeral hatchments (diamond-shaped wall tablets with coats of arms of the deceased) in Cornwall, a 1710 pulpit with tester sounding board above inscribed 'Blessed are they which hear the word of God and keep it', Madron church still feels Georgian. Only a handful of beast-headed early sixteenth-century bench ends survived being used as box pew bases by the Georgians.

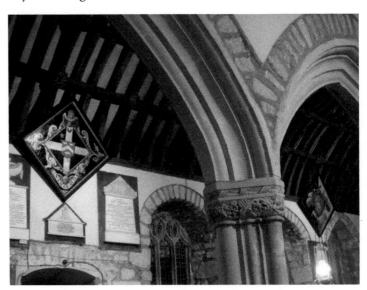

Madron.
Wave-moulded piers,
Devonian capitals,
and hatchments.

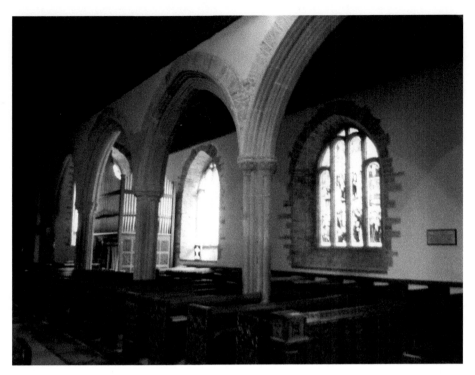

Morwenstow. 1564 south arcade.

this has the same tracery-less windows from the final phase of Perpendicular architecture as the 1564 south aisle.

Despite its remoteness, Morwenstow parish has many old houses and significant families. Rectory farm, formerly owned by Bridgewater Priory, has been dendro-dated to the early fourteenth century, one of the oldest surviving buildings in Cornwall. John Stanbury, Bishop of Hereford, was born at Stanbury in Morwenstow. In 1473 he left a cross of silver gilt to stand on the altar of Morwenstow church and to be carried in procession here (well before the processional aisles were created). Tonacombe next door to Stanbury was home to Thomas Kempthorne, whose initials appear on a 1573 Morwenstow bench end.

34. MYLOR – GRAFFITI-VILLE (36)

For graffiti afficionados, St Melor's, Mylor, is the Cornish church to visit. Its Beer limestone-panelled porch of classic west Cornwall type, south door and stoup are thoroughly defaced with merchants' marks carved into the soft stone, while the chancel and south chapel arcade tend to have initials and dates from the 1540s on. Richard Trefusis, the lord of the manor, signed his name in an elegant hand high up on the pier nearest to the south door for all to see. Named individuals also include Henri Reffinton (a possible merchant), Edmond Rydall, John Dighbie and Thomas Harris in the late sixteenth century, none being local names. Apart from merchants trading up the River Fal to Tregony and Truro, who were the graffiti carvers? It is possible that one or two may have been friends of Trefusis,

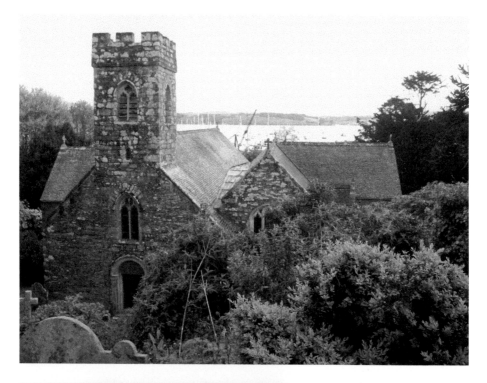

Above: Mylor. Creek-side church.

Left: Mylor. Graffiti.

and JB 1651 may have been an iconoclastic soldier from Pendennis Castle intent on window or font smashing. Interestingly, the present font is octagonal and seventeenth century in date.

Mylor has two crosses, a very tall Norman one which propped the church up before the 1869 restoration, and an early fifteenth-century possible lantern cross, very worn, and now reset, on the east side of the north transept. Murals of fourteenth-century date were also found during this restoration, and destroyed when the north wall was rebuilt. To the right of the north door was a St Christopher, but only his bushy beard, arm, staff and Christ's tunic hem and feet survived to be drawn by William Iago. Above this were two or more figures in long gowns or vestments but without heads. Beheading occurred as the original Norman church was lowered in height when the early sixteenth-century south aisle with its tracery-less windows was added (a 1513 bequest may relate to this). This deliberate lowering of walls has major implications for the study of Cornish church architecture. It could have occurred when the rood screen was installed in the 1520s–30s. The rood screen base, inscribed for the figures of Mary, John and Jesus Christ on the Cross that once stood at the back of the rood loft or on a rood beam above, still survives. Were Cornwall's Norman churches of greater height than their rather squat, and chancel-arch lacking, Perpendicular successors? The answer in many cases must be yes.

35. St Neot – Key Launch-Pad (3)

The best interlace (woven band) carving in Cornwall and granite use at its best is to be found at St Neot on Bodmin Moor. The churchyard cross is like the

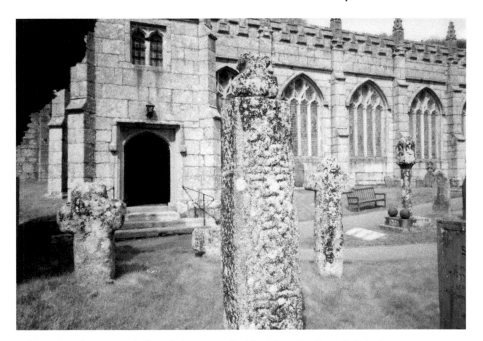

St Neot. Interlace cross shaft and showy south side. (Photo by Peter Brierley)

nearby Doniert Stone, the tombstone of the Cornish King Dungarth who died in AD 875. St Neot's cross shaft lay against the south wall of the church with its base stone opposite the porch, the two parts being reunited in 1889. Folklore of the eighteenth century relates that St Neot, due to his dwarfish stature, had to stand on the base stone and hurl the key at the church door to gain entry. The cross's real significance is as a marker of the important early monastic site of St Guerir (later St Neot) visited by King Alfred while hunting.

St Neot is internationally important for its late medieval stained-glass windows largely paid for by the local tin industry. Second only to Fairford, Gloucestershire, for completeness, St Neot's windows are more typical of parish church glazing. Starting with a mid-fifteenth-century chancel window, the Lady chapel glazing is 1480s–90s, with the rest of the south aisle following in the 1500s–10s. Glazing resumed in the 1520s with the north chapel, and the last three aisle windows were formerly dated 1528–30 running westwards. Chancel and nave were then re-roofed in the 1530s–40s, and repaired in 1593. In 1825–29 J. P. Hedgeland restored the stained glass and added four windows with much shuffling around since.

International saints are most common, though local saints were chosen for some of the north aisle windows. Four more costly windows having twelve to

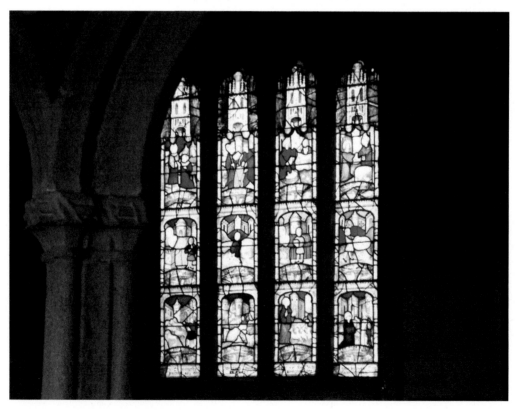

St Neot. Patron saint's window.

St Neot. Fish legend roof bosses.

twenty individual scenes once covered the Old Testament from the Creation to Moses (as at Great Malvern, Worcestershire), though the second ends now with Noah's death, and the lives of St George and St Neot. So popular was the patron saint's legend that it was extended to four of the five wooden roof bosses above the previous window. Three fish appear in swirling water, then one, then a fish on a gridiron, and finally two fish served up on leaves. This refers to an angel giving three fish to St Neot with instructions to take only one a day. When the saint fell ill, his foolish servant Barry took two fish from the holy well and cooked them in different ways to tempt his master to eat. These miraculously came back to life when thrown back into the well, fortunately. The 1330s Easter sepulchre made by Exeter Cathedral masons doubled as St Neot's tomb with him and St Guerir presumed to be the haloed kneeling figures.

36. NORTH HILL – ROYAL MARRIAGE BUNTING (25)

In 1495 sixteen-year-old Katherine Plantagenet, the second youngest daughter of Edward IV and Katherine Woodville, married twenty-year-old William Courtenay, Earl of Devon, at Westminster. For Katherine's family, William was a poor third choice after foreign marriage negotiations failed, but for the Courtenays this love-match marriage brought disaster. William died in 1511, two years after his release from a lengthy spell in prison; Henry, the only son of the marriage, was executed for treason in 1538; and Henry's son William died childless in 1556, having spent most of his life in prison. Such was the price paid by those too closely related to Henry VIII.

Katherine spent the last fifteen years of her life after her husband's death until her own death in 1527 as the Princess Katherine, daughter, sister and aunt of kings, holding court at Tiverton Castle in Devon. There she was defended by two great guns in the gatehouse and entertained by a parrot in a cage. All this was in the future when the parishioners of St Torney, North Hill, celebrated the royal link with their parish. Landreyne manor, North Hill, belonged to the Courtenays, but whether William and Kate ever visited is unclear. Along

Left and below:
North Hill.
Courtenay arms,
and Courtenay,
Plantagenet and
Neville badges.

the oak wall plate of the north chapel and aisle roof a carpenter carved the
Courtenay arms (*see* St Austell), their bundle of faggots badge, the Plantagenet
fetlock badge, and the ragged staff badge (*see* Fowey) of Katherine's Neville
grandmother.

North Hill church is an architectural gem, despite the Georgian destruction
of window tracery. Following closure in 2019, this church is now vested in the
Churches Conservation Trust. In the early fourteenth century the Dawney family
of Sheviock held the advowson and made North Hill's chancel one of the most
elaborate in Cornwall, with four statue niches, triple sedilia, piscina, a shelf with
traceried-niches below, and an ogee-arched tomb canopy or Easter sepulchre. The
tower has Flamboyant carvings and the magnificent granite ashlar south aisle
is battlemented, buttressed and pinnacled and historically linked to the Spoures

40. PROBUS – AMBUSHING PARISHIONERS (29)

On Monday 5 January 1523 Nicholas Carminow's men ambushed Probus parishioners while they were carting stones for church works. Another Carminow-inspired attack on Thursday 22 January 1523 left parishioners Richard Benatt and William Trewethan badly beaten. The context for both cases was a bitter struggle for parish ascendancy between Nicholas Carminow and his brother-in-law John Tregian (*see* St Ewe), who had married co-heiresses of Wolvedon alias Golden. Nicholas complained in 1521 that twenty-two parishioners had trespassed on his land at Gweal Martin. He also alleged that Tregian, a Truro tin merchant turned gentleman with several liveried servants, had promised to spend £1,000 to bring him to poverty. Churchwardens of St Probus answered that Nicholas and his wife had been overheard by their servants saying that they would make the parish beg for their bread before they allowed them to build the church. Clearly plans for a 126-foot-tall Somerset-style tower, the tallest and most ambitious in Cornwall, costing £33 6s 8d per year in the first three years alone, irked the Carminows. Gentry arbitration on 9 October 1523 allowed building work to resume with Reynard the fox pursued by hounds carved along the north tower plinth. Although eventually finished several years later, no coats of arms appear on the tower in contrast to the church interior where forty-five coats of arms were

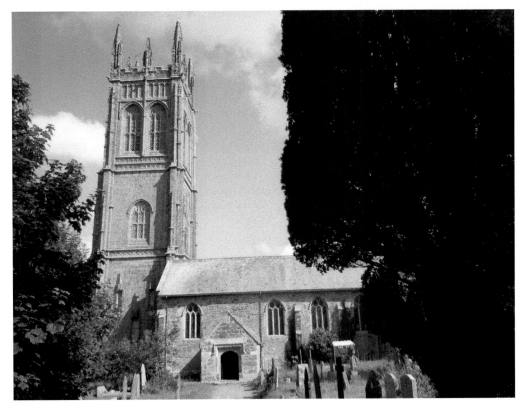

Probus.

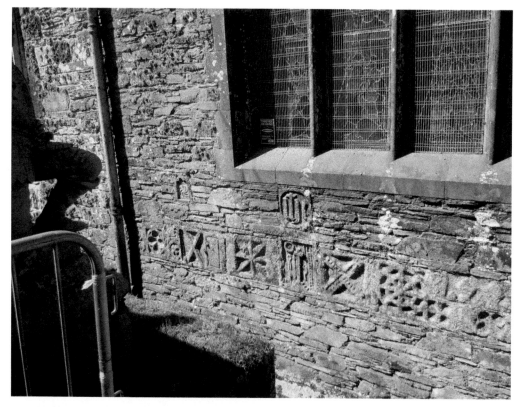

Probus. Carved stones below chancel window.

once painted on shields on the pillar capitals. What this Star Chamber case shows is that voluntary parish labour kept costs down. Stone was stockpiled for the mason's use ahead of the building season. Quarries included Gweal Martin, a mile from the church on the road to Ladock, and an unnamed freestone quarry 4 miles away where the ambush took place. Finer-grained granite came from St Stephen in Brannel parish.

Probus was an important church with early sanctuary rights, and its church aisles and north or Jesus chapel have mid-fifteenth-century piers with attached shafts and wave-mouldings (*see* Madron). Carved stones on the chancel's outside east wall include a crucifix with symbols of the Passion below a *c.* 1520 Lanlivery-type east window, suggesting that a full upgrade of this major church began at the same time as the tower. The south chapel was not built until 1904, leaving the Tregians buried further west in Probus church than their Carminow rivals.

41. REDRUTH – GOING CLASSICAL (44)

St Euny's, Redruth, is that rarity among Cornish churches: a Classical-style church, which people either like or loathe, approached through a picturesque crenellated Gothick lychgate. Lying in a delightful rural church-town setting a mile or more from Redruth, the site of St Euny, with its oval churchyard or lann,

may go back to the sixth century AD. The medieval church was pulled down, apart from its gargoyle-infested tower, during the incumbency of the Reverend John Collins MA, a friend of John Wesley, and rebuilt as an urban church to reflect the enhanced tin and copper mining status of the town. Work on rebuilding the nave was noted in 1756, and another faculty agreed in 1766 for further rebuilding work. Plans were drawn up by Charles Rawlinson, architect, and reseating was done in 1768–70. Slate commandments, Creed and Lord's Prayer were bought for the chancel to frame its striking Venetian east window and in 1798 the church was lit with chandeliers. Georgian wooden sash windows with half-windows below reverse the medieval concept of a clerestory, where the smaller windows are invariably above. Gallery and roof-supporting double rows of Doric columns and a flat ceiling under three continuous gabled roofs give a feeling of spaciousness.

A sketch made shortly before the rebuilding shows St Euny's Redruth as a typical Cornish three-hall church. It is possible that the original Norman church, of which only a corbel head and cross fragment survive, had an apsed or semicircular east end. Heraldry of the Bassets of Tehidy was noted in 1751–53 by William Borlase, the antiquarian rector of Ludgvan, on the south side when he visited, with an earlier Basset arms in the east window. Borlase also drew an early Christian stone inscribed 'MAVORI FI[LI] VITO' found in the east wall of the chancel and now

Redruth.

lost. In 1448 Reginald Mertherderwa, former rector, gave vestments to the church, possibly to endow a side altar. Devon-style foliage capitals like Camborne remain at the back of the church. The early sixteenth-century tower has a tracery-less west window, four-centred door, with angel corbels supporting tracery panelling and pinnacles.

42. SHEVIOCK – TRANSEPTAL TOMBS (11)

Rather like shunted trains in sidings, the tombs of heiress Emmeline Dawnay and her husband, Edward Courtenay, who died in 1370 and 1372 still hug the south wall of the south transept at St Mary's, Sheviock. They lie with a wall separating them and her feet close to the piscina where the family altar would have been. With quatrefoils and shields on the base and a transept-wide canopy with blank cusped arches above, this is the finest surviving Cornish tomb ensemble and the apogee of Decorated Gothic work. Both tombs date from around 1378 when Edward and Emmeline's son Edward Courtenay were the 3rd Earl of Devon. He also put up a matching tomb in the north transept to his grandfather, Sir John Dawney, knight, who died in France in 1346, just before the Battle of Crecy. The north transept was lost when an aisle was made in the late fifteenth or early sixteenth century.

Both male effigies wear armour with belts of enamelled plates and helmet pillows. Emmeline has a mantle over a gown, sideless-surcoat, and an unusual square headdress with floral motifs. Similar headgear can be found at Newland, Gloucestershire, and Ottery St Mary, Devon. Emmeline's head rests on two

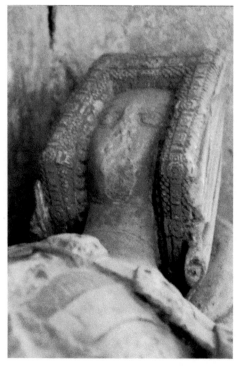

Sheviock. Lady Emmeline's bonnet. (Photo by Peter Brierley)

Sithney. North chapel inner arch window decoration.

chapels at Cury and Padstow. John Urban was the son of a Helston merchant, who married Joan Reskymer of Merthen in Constantine. He was an administrator in Calais and lieutenant of the Admiralty, before settling in Kent. In 1420 John left £10, vestments, a chalice and missal (Latin mass book) to Sithney church in return for prayers and £40 to employ a chaplain at £4 13s 4d each year for nine years. John, his much-loved wife and his father were to be specially prayed for at Sithney.

The Urban chapel also housed the tomb of St Sithney. Was the bonnet of blue silk, listed in the 1549 church inventory, used to dress his statue on his feast day? Two green streamers, and blue, red, and yellow vestments added colour to the church, as did stained glass. Glass heads of an Old Testament prophet, and the Virgin and angel Gabriel from an Annunciation still survive, with part of a fifteenth-century Trinity alabaster reredos panel. Sithney's unbuttressed tower with carvings of the four evangelists must date from around 1500, but building work continued well into the 1530s with a pair of additional transepts like Breage and a five-panelled West Cornwall porch includes chevron carvings from the Norman doorway this replaced.

44. SOUTH PETHERWIN – SHODDY WORKMANSHIP (16)

In 1456 John Gedde, mason, of St Stephen by Launceston made an inadequate new belfry window at St Patern's church, South Petherwin, and had to pay £6 13s 4d in damages. The belfry window may be that on the east side of the tower which is not set symmetrically because of an awkward stair tower projection on the north-east corner. Towers were parish status symbols and usually sources of parish

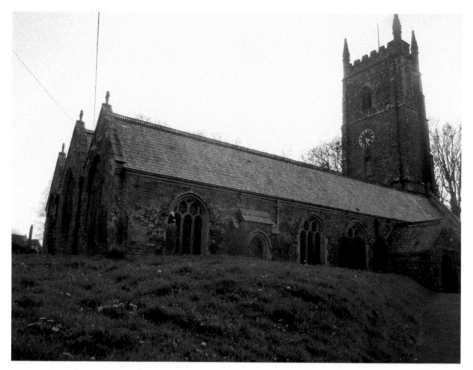

South Petherwin. Asymmetrical tower.

pride, though perhaps not here. South Petherwin did achieve the rare distinction of a symmetrical east end, with matching Cornish standard Perpendicular windows. William Gedy, possibly a relation of John, the St Stephen mason, gave lands at Drenek in the parish worth around 16*s* 5*d* for a Jesus mass every Friday in the early sixteenth century. This mass was held in the north chapel, and run by a Jesus guild and store. In 1544 there were also guilds of St George, St John and St Mary, and another guild of St Mary at the daughter chapel of Trewen.

Thomas Menwinnick, vicar (1442–62), founded a chantry at South Petherwin in the south chapel, which was dissolved in 1548. This foundation followed the rebuilding of a Norman north aisle as a Decorated-period one, and the moving of the Norman north door. The last Menwinnick chantry priest John Lucas received a salary of £5 6*s* 8*d*, Oxford student; Gentile Graynfelde (Grenville) of Stow, Kilkhampton, got a grant of £2 each year; a poor man received £1 10*s* 4*d*; and £1 was used to repair the chalice and mass gear. Two versions of the Tremayne arms, three hands, and then a chevron between three escallop shells once appeared in glass in the chantry chapel suggesting that this family took over Menwinnick's chantry. Tremaynes occur in South Petherwin as early as 1414 when Elinor Tremayne fought with her neighbour Joan Langdon in the church, an action which led to the withdrawal of church services for a time. Tremayne, Treguddock and Wise arms appear on bench ends and commemorate the marriage of Richard Tremayne of Upcott and Treguddock and Jane Wise. In 1522, Richard's goods were valued at £66 13*s* 4*d*.

St Teath. 1630 tower. (Photo by Peter Brierley)

nave and chancel were also re-roofed according to dendro-dating. The south aisle is probably of 1500s date and bench ends were installed in the 1510s. Surviving stained glass includes the five wounds of Christ, and the Mohuns of Tregardock once displayed their full lineage in stained glass here, as elsewhere.

47. TINTAGEL – CHURCHYARD CHAPEL (4)

When they visited St Materiana's church, Tintagel, in the early 1800s, Daniel and Samuel Lysons noted 'remains of buildings in the churchyard earthwork'. In 1991 Charles Thomas and Jacky Nowakowski excavated the foundations of an eleventh-century single-cell church or chapel on the north side of the present church. Chapels in churchyards are not uncommon in Cornwall and most were used to store loose bones, like St Thomas Becket chapel, Bodmin. The Tintagel churchyard excavation turned up part of an early Norman tub font which was replaced by a square late Norman five-shaft font with roughly carved serpents linking four corner heads. Tintagel churchyard may have been the Dark Age burial ground for the elite settlement on Tintagel headland, but inconveniently lies a mile or more away from the shrunken medieval borough that once extended to Bossiney. In the valley between the church and borough lies the old vicarage with its round medieval dovecote. Was this where Joan Kelly, described on her brass as the vicar's mum, died around 1430?

Churches in Cornwall do not get much simpler in plan than Tintagel, so it is surprising that this church once had a medieval organ in its rood loft. Tintagel was one of Cornwall's poorest parishes by the early sixteenth century so it is likely that most Cornish rood lofts once housed organs. Whether Tintagel's organ was still played in 1613, when noted in a list of church ornaments as a 'chest for

organs with a certain number of pipes and a pair of bellows thereto belonging', is unclear. The massive oak rood screen that once supported this organ survives and has a scribed joint, where rail meets post, suggesting a 1530s date. In 1548 certain masses and dirges were celebrated at Tintagel with polyphonic or multi-part organ music providing interludes between the singing.

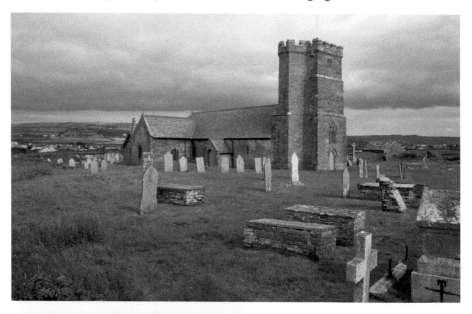

Above: Tintagel. North side with earthworks.

Left: Tintagel. Interior and rood screen.

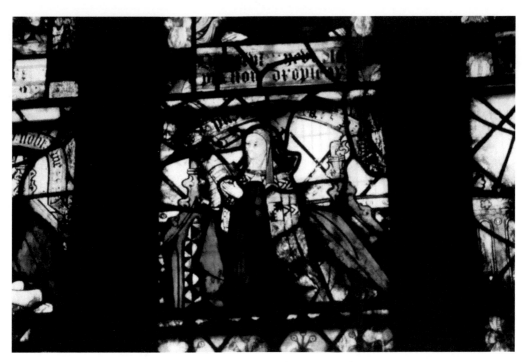

St Winnow. Phillipa Kayle, later Carminow. (Photo by Peter Brierley)

St Winnow Barton appeared in their north transept chapel, and the east window has an early sixteenth-century crucifixion scene with Cullompton-style Golgotha.

A rare 1281 inventory for St Winnow shows a well-equipped church, with silver chalice, two sets of vestments, surplice, altar and corporal cloths for laying sacraments on blessed by the Bishop of Exeter. Other items were a pix, chrismatory (consecrated oil container), little tabernacle for the reserved sacrament, an iron to make the host, three tin leaves, a font with a lock (to prevent holy water theft), a wooden processional cross, Lenten veil, censer, holy water stoup, ten service books, four bells, a wheel with jingling bells, and a chest. By 1331 the church goods were worn out, the font had no lock, but there were wedding and funeral palls, a banner, and badly painted pax with crucifixion image for kissing during mass.

Bench ends continued to be carved here well into the seventeenth century. One of the earliest may show William Lower's ship lost in 1525 to the French.

GLOSSARY

Advowson	right to choose priest.
Chantry	endowment for priest to sing masses for founder's soul.
Clerestory	high-level windows.
Corbel	projecting carved stone.
Cusp	projecting point in Gothic tracery.
Dendrochronology	dating technique based on annual variation in tree growth rings with an allowance added for sap rings removed by carpenters.
Donative	benefice given directly without involving bishop.
Easter sepulchre	tomb chest for re-enacting the Resurrection at Easter.
Guild	mutual self-help group.
Hood mould	moulding over arch designed to throw off rainwater.
Indulgence	Papal grant of remission of time spent in purgatory, usually forty days.
Label	three-pronged heraldic marker for eldest son or horizontal termination of hood mould.
Lann	early Christian oval churchyard.
Obit	mass marking anniversary of a death.
Ogee	double reverse curve arch drawn with four compass points like four-centred arches.
Respond	half-pillar.
Rood screen and loft	painted and carved division between chancel and nave, supporting crucifix or rood and rood stair accessing loft where organ housed.
Scribed joint	moulding shaped to fit profile of another.
Squint	opening through wall allowing view of high altar.
Store	goods and animals rented out or sold to fund church works.
Tabernacle	canopied statue niche.
Transepts	chapels attached at right angles to nave to make church cruciform.
Wall plate	load-bearing beam, often highly carved, resting on top of wall.

BIBLIOGRAPHY

Beacham, Peter and Pevsner, Nicholas, *Cornwall* (New Haven and London: Yale University Press, 2014).

Blight, J. T., *Churches of West Cornwall with Notes of Antiquities of the District* (Oxford & London: Parker and Co., 2nd edn, 1885).

Brown, H. Miles, *The Church in Cornwall* (Truro: Oscar Blackford, 1964, rep. Mount Hawke, Cornish Classics, 2006).

Henderson, Charles, *The Cornish Church Guide* (Truro: Oscar Blackford, 1928).

Holden, Paul (ed.), *New Research on Cornish architecture – Celebrating Pevsner* (London: Francis Boutle Publishers, 2017).

 What is unique about Cornish buildings? Proceedings of the 2019 CBG conference (Donnington: Shaun Tyas, forthcoming).

Mattingly, Joanna, 'The Dating of Bench-Ends in Cornish Churches', *Journal of the Royal Institution of Cornwall*, 1991, pp.58-72.

 'Stories in the Glass – Reconstructing the St Neot Pre-Reformation Glazing Scheme', *Journal of the Royal Institution of Cornwall*, 2000, pp.9-55.

 Looking at Cornish Churches (Redruth: Tor Mark Press, 2005).

 Cornwall and the Coast - Mousehole and Newlyn (Chichester: Phillimore, 2009).

 (ed.), *Stratton Churchwardens' Accounts 1512-1578* (Woodbridge: Suffolk, Devon and Cornwall Record Society and The Boydell Press, 2018).

Orme, Nicholas, *Cornish Wills 1342-1540* (Exeter, Devon and Cornwall Record Society, 2007).

 Cornwall and the Cross – Christianity 500-1560 (Chichester: Phillimore, 2007).

 A History of the County of Cornwall, vol. II, *Religious History to 1560* (Woodbridge: Suffolk, Boydell & Brewer Ltd, 2010).

 Going to Church in Medieval England (New Haven and London: Yale University Press, 2021).

Preston-Jones, Ann and Okasha, Elisabeth, *Early Cornish Sculpture* (Oxford: Oxford University Press, 2013).

Sedding, Edmund H., *Norman Architecture in Cornwall* (London: Ward & Co., 1909).

Thomas, Charles, *And Shall These Mute Stones Speak? Post-Roman Inscriptions in Western Britain* (Cardiff: University of Wales Press, 1994).

Warner, Michael, *A time to build. Signposts to the building, restoration, enhancement and maintenance of Cornwall's Anglican Churches, 1800-2000* (Linkinhorne: Scryfa, 2022).

Wilson, Helen, *From 'Lady' Woodcarvers to Professionals - The Remarkable Pinwill Sisters* (Plymouth, Willow Productions, 2021).

ACKNOWLEDGEMENTS

Thanks to John Allan, Caroline Barron, Eric Berry, Linda Beskeen, Stuart Blaylock, the late Peter Brierley, the late Chris Brooks, Angela Broome, Allen Buckley, Emma Carlyon, Paul Cockerham, the late Pam Dodds, Christine Edwards, John Gould, Todd Gray, Paul Holden, Alex Hooper, Andy Jones, Alexis Jordan, Graeme Kirkham, Andrew Langdon, Lesley Laws, Anna Lawson-Jones, Bob Moore, Patrick Newberry, Helena Nightingale, Jacky Nowakowski, the late Cathy Oakes, Mike and Tina O'Connor, Nicholas Orme, Oliver Padel, Pat Penhallurick, Ann Preston-Jones, Konstanze Rahn, Bryony Robins, Nigel Saul, the late John Scott, Cynthia Stanford, Michael Swift, Caroline Tetley, David Thomas, Sue Thorold, Carole Vivian, Michael Warner and Alex Woodcock. I would also like to thank the Cornish Buildings Group, Cornwall Historic Churches Trust, the Diocesan Advisory Committee, my students and the people of the parishes who made me so welcome.

43. SITHNEY – CIST GRAVE (2)

Rothwell Historical Restorations were in for a shock when they took up a Victorian tiled floor in 2018 at St Sithney's near Helston. Instead of the expected handful of bones, they discovered many eighteenth- and nineteenth-century skeletons under the floor. The Diocese of Truro *News* reported: 'Perhaps not as significant as the discovery of the skeleton of Richard III in a carpark ... these were people nevertheless, just as deserving of a high degree of dignity and respect'. Once the police and coroner were convinced that the remains were not recent or suspicious a public viewing was allowed on 30 August and a limited excavation led by James Gossip of Cornwall Archaeological Unit followed in 2018–19. The most exciting find was a cist burial underlying the foundations of an earlier chancel, which was narrower than the present nave. This stone-lined grave or chest was radiocarbon dated to the eighth century AD.

The north-east chapel has more lower-pointed arches than the rest of the church with clustered piers and leafy Devon-style capitals like Breage. Its east window has a shallow arch, typical of the early fifteenth century, bulbous mouldings and an inner arch panelled and decorated with quatrefoils and cusped St Andrew crosses. Here a chantry of daily masses was founded by John Urban, esquire, of Southfleet, Kent, in 1420 and this chapel seems to be the prototype for Nanfan chantry

Sithney.

cushions, while her feet rest on beasts. Surviving medieval glass shows the Courtenay arms with a three-point label, and part of a Virgin Mary. A 1961 John Wesley peeps out from the tower lancet window.

Sheviock is an unusual Cornish church with less Perpendicular architecture than most and some excellent Decorated-period features. In addition to the transepts and tombs there is a complete chancel with sedilia, piscina and nodding ogee statue niche for the patron saint, an east window like Gwinear and Lostwithiel, transeptal windows with five-point stars in a circle, and a spire. Sheviock church is dedicated to the Virgin Mary rather than a local or Brittonic saint. The bench ends are also unusual, having Devonian tracery decoration and only an occasional Renaissance-style arabesque end.

Sheviock. Spire.
(Photo by Peter
Brierley)

45. STRATTON – BLANCHMINSTER'S AISLE (10)

It is unusual to have a precise date for an aisle but at St Andrew's, Stratton, in 1348 Ranulph Blanchminster, knight, left £6 13s 4d to build one. He also left timber at Downrow in Whitstone for the lean-to roof, around half the width of the present north aisle, as well as vestments for the Lady chapel altar at its east end. Only three or four stumpy Polyphant piers and a respond survive of the Blanchminster aisle, together with an ancestral tomb of a cross-legged knight, a leftover from an earlier north transept chapel. The late thirteenth-century effigy represents either Ranulph's father Reginald or grandfather Ralph. The Blanchminsters lived at Binhamy in Stratton, which Ranulph fortified in 1335 with a moat, but he also held the manor of Wighill in Yorkshire. At Stratton, two priests were to celebrate a requiem mass and a Trinity mass for Ranulph's soul, and five other masses were to be said in churches including Week St Mary. Ranulph left six books mostly in French, a mixture of religious instructional books, histories and romance, to women. Were these women literate, or did a male servant read aloud to them?

The High Cross wardens' accounts of Stratton survive from 1511–12 when the south aisle was nearing completion. In 1531–38, the insertion of a new rood screen and loft involved the raising and widening of the north aisle and creation of the first seats. Wardens went to St Columb Major, St Kew, Liskeard and Week St Mary to find models for components of their rood loft. As late as 1544–46, the chancel and Lady chapel were pulled down and rebuilt.

A clock (*see* St Austell) was bought for 10s in 1512–13, to regulate Stratton's new market below the churchyard. With fairs and shops, Stratton soon replaced Week St Mary and Kilkhampton as North Cornwall's premier shopping centre. On

Stratton. (Photo by Alexis Jordan)

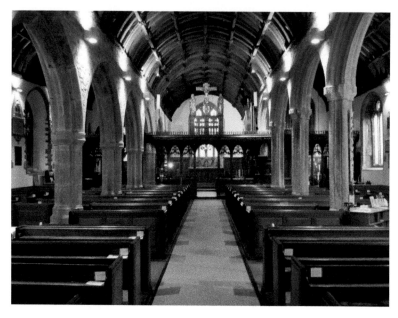

Stratton. Interior
with early aisle
on left.

the opposite side of Stratton's triangular marketplace lies the impressive church house built in 1515–16 for the brewing of church ales. Gypsies were among the entertainers who used the church house at fair times. In November 1560 the upper hall of this building was the setting for the funeral wake of Sir John Arundell, knight, of Efford and Trerice.

46. ST TEATH – LAUDIAN TOWER (40)

St Teath's three-stage tower has a four-centred west door with hood mould and square labels carved with 16 and 30 in relief. This date also appears on the pulpit with the coat of arms of the Carminows and their Cornish motto, 'Cala rag whetlow' meaning 'a straw for a tale bearer'. William Carminow, esquire, of Trehannick in St Teath, who died in 1671, was the last of this line. The tower is a bit of a mystery as its walls are thick, so a rebuild rather than new build is likely, but with a major aisled church here in the Norman period, the first tower may have been a central one. Earlier Carminows were based at New Hall, like Sir Ralph Carminow, knight, who on 9 October 1386 chose to go hunting rather than attend the opening of Parliament, and was killed when his greyhounds pulled him over a cliff. St Teath's windowsill effigy, often mistaken for a nobleman or priest, represents Ralph Carminow's widow Alice. Five times married and widowed (Ralph was her third husband and she was his second wife), Alice's head is supported by angels. Although at least seventy when she died in 1426, Alice's effigy had rich brown curls, a light brown or amber outer robe and red undergarment. Alice's last husband, Sir William Bonville, knight, who died in 1408, left 20s in his will to a religious hermit who dwelt at Steth.

As well as the hermit, there was a vicar living a mile from the church, and two non-resident prebends until 1547. The church was supported by a 1381 indulgence and the northern Norman aisle remained until the 1540s, when the

48. TRURO, OUR LADY OF THE PORTAL & ST PIRAN – TWENTIETH-CENTURY INTERIOR (50)

Partly inspired by a Byzantine church with a full-width entrance hall at the front, the modern Roman Catholic church of Truro occupies a site near that of a former medieval guild chapel. This chapel stood in St Clement's Street, Truro, near Old Bridge at the eastern entrance to the town. The present church was dedicated on Thursday 17 May 1973 with water from a natural spring, now the church well. At this time members of the Fraternity of Our Lady of the Portal included Peggy Pollard, an Oxford blue-stocking and un-orthodox National Trust fundraiser. Designed by John Taylor + Associates, this church has an enclosed meeting place and symbolic twenty steps entrance with a crucifix by Michael Finn. The glory is inside, under a vast wooden roof, where stained-glass slit windows cast an atmospheric glow whatever the weather. The windows were made by Dom Charles Norris OSB of Buckfast Abbey in fiery oranges and yellows, with blues and mauve reserved for St Mary's shrine chapel. Roman Catholic worship in Britain began afresh around 1850. St Mary Portal replaced an 1885 church of St Piran on Chapel Hill, when the growth of tourism led to over-large summer congregations.

The medieval chapel of St Mary of Portal is first noted after 1400, when St Mary's parish church, Truro, received a valuable indulgence from the Pope. This gave Truro privileges equal to Assisi in Italy, amounting to a full pardon of all penance, but only available on Trinity Sunday and Michaelmas Day. In 1420 John Bakere left 12*d* to the Blessed Marie de le Portell, with bequests of 3*d* and 20*s*, including an image, in 1448 and 1528. By 1440 the chapel had a guild and keepers and in 1545 a house and garden in 'Strete Clemens'.

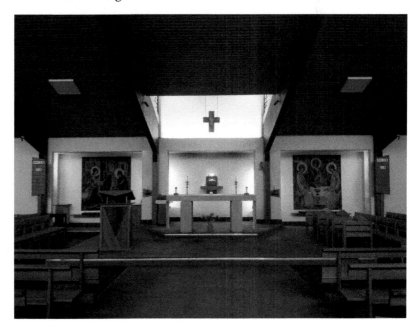

Truro, Our Lady of the Portal and St Piran.

49. St Veep – Dendro-architectural Mismatch (18)

After a fall of Georgian plaster from the tower end of the nave roof, in 2005, St Veep became the first Cornish church to be dendro-dated. Nave, chancel and south aisle roofs appear to date from the 1460s. Previously the south aisle was dated to the mid-fourteenth century, its piers having four demi-shafts and four sharply keeled minor shafts between like Poughill. This earlier dating

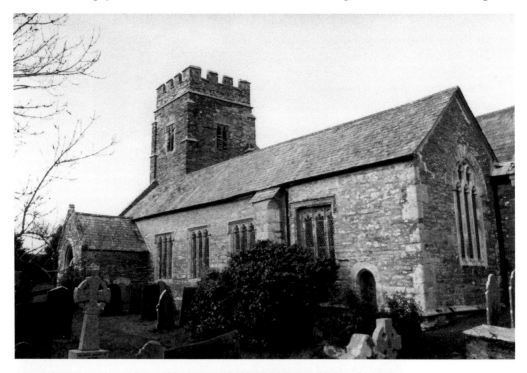

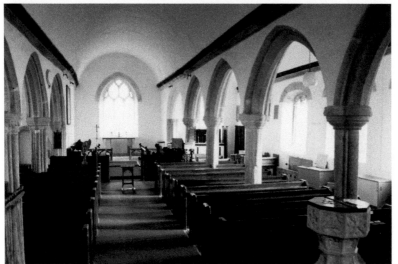

Above: St Veep. (Photo by Peter Brierley)

Left: St Veep. Piers pre-dating dendro-dates. (Photo by Peter Brierley)

is likely to be right, with the 1460s date merely representing the widening and heightening of the aisle. A 1504 bequest ties in with the square-headed mullion window frames, though these are nineteenth-century copies. Dendro-dating of the north aisle was also problematic as the piers of four major and four minor shafts and Devon-style foliate capitals are early to mid-fifteenth century stylistically and not 1540s like the roof. Widening of an existing aisle is the most likely explanation, but recycling an aisle from St Carroc's priory in this parish, which was dissolved in 1539, is also possible. Lawrence and Dorothy Courtenay, who acquired St Carroc in 1545, were patrons of the St Veep living.

William Pope was vicar of St Veep in 1454–72 when the chancel and nave were reroofed, and Richard Bennett, vicar in 1531–49 when the north aisle was reroofed or recycled. Bennett was also vicar of St Neot from 1544, and was executed with John Wynslade in 1549 as a rebel leader. In 1548, St Veep parishioners had been forced to sell two chalices to send parish horsemen to put down the Helston commotion, while in 1547 John Wynslade had accused Bennett of keeping a concubine called Jane Erle for ten years at St Veep vicarage and having several children by her. Wynslade claimed that when Jane died around 1544 she was secretly buried under the pews at St Veep. Five Tudor benches still survive, with original backs and seats, and include an unusual ragged cross motif and Devon-style tracery.

St Veep. Bleached benches.

50. ST WINNOW – MARRIAGE CONTRACT-DATING (19)

Some years ago, Angela Broome, then Courtney librarian of the Royal Institution of Cornwall, showed me the marriage contract of William Kayle, esquire, of Ethy in St Winnow and Phillip or Phillipa, daughter of John Trenoweth, esquire. This pre-nuptial agreement was drawn up on 18 October 1463 at the bride's home of Fentongollan in St Michael Penkevil parish. Phillipa's lands were worth £23 6s 8d, with £13 6s 8d to come from William Kayle, and a £100 dowry. Like most medieval marriages, the service on 16 October 1464 began in the porch (at St Michael Penkevil) with a church mass afterwards. William Kayle gave £8 of land to re-found his grandfather Ralph Kayle's 1419 chantry at St Winnow and died childless. This second Kayle chantry lasted until 1538 and still contains some of the best Exeter-made stained glass in Cornwall – a medley of more than one window. William Kayle is shown with shoulder-length blonde hair kneeling at a prayer desk wearing armour and an armorial surcoat and praying to St George. His wife Phillipa's mantle has Kayle arms impaled with Trenoweth on her shoulder. St George and St Michael appear to be William Kayle's 1460s additions, but other saints in this window could be early fifteenth century from an earlier chantry chapel. By 1470 at the latest, Phillipa had married John Carminow of Bodmin and they had nine children (*see* St Kew and Probus). In 1492, John Carminow left £1 to St Winnow, and could be the red-gowned donor figure with a prominent purse. Other heraldry here includes Courtenay and Foster arms dating to 1580 and the nineteenth century. The distinctive three rose and chevron arms of the Lowers of

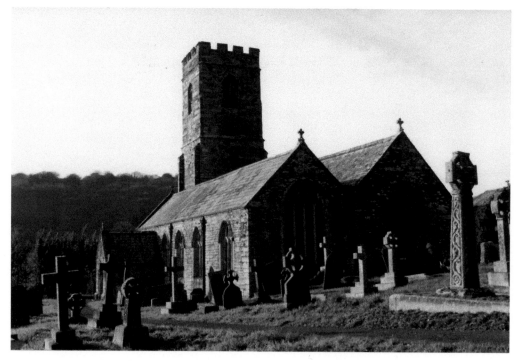

St Winnow. (Photo by Peter Brierley)